IMAGES
of America

BOWLING GREEN

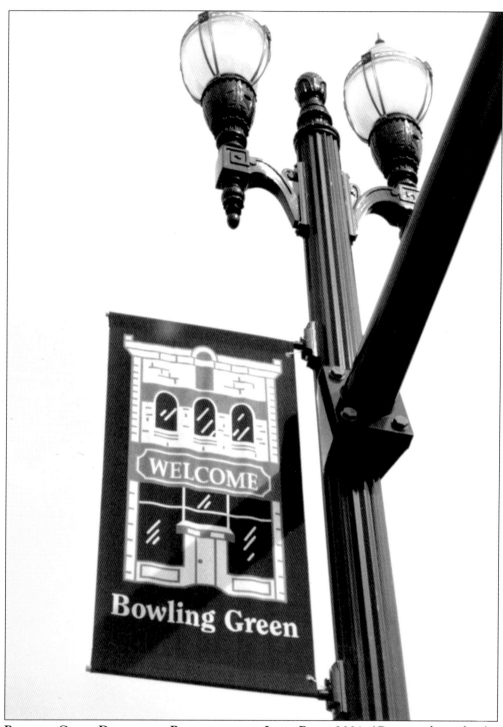

BOWLING GREEN DOWNTOWN REVITALIZATION LAMP POST, 2001. (Courtesy the author.)

IMAGES
of America

BOWLING GREEN

Frederick N. Honneffer

ARCADIA
PUBLISHING

Published by Arcadia Publishing
Charleston SC, Chicago IL, Portsmouth NH, San Francisco CA

Printed in the United States of America

Library of Congress Catalog Card Number: 2003115618

For all general information contact Arcadia Publishing at:
Telephone 843-853-2070
Fax 843-853-0044
E-mail sales@arcadiapublishing.com
For customer service and orders:
Toll-Free 1-888-313-2665

Visit us on the Internet at www.arcadiapublishing.com

–

Dedicated to the memory of Mrs. Naomi Greenfield,
a longtime friend to Bowling Green.

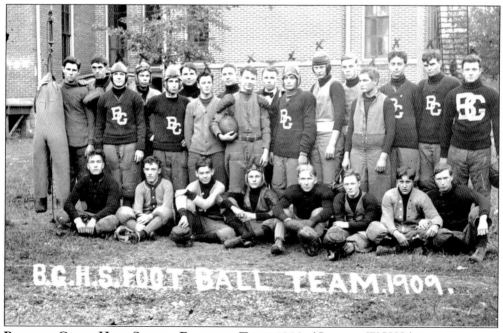

BOWLING GREEN HIGH SCHOOL FOOTBALL TEAM 1909. (Courtesy WCHS.)

CONTENTS

ACKNOWLEDGMENTS

The majority of images appearing in this book were loaned by the Center for Archival Collections at Bowling Green State University (CAC-BGSU), the Wood County Historical Society (WCHS), the Wood County District Public Library (WCPL), and the Bowling Green *Sentinel-Tribune*. Additional sources are noted with individual images.

The author is especially grateful to these organizations for their willingness to share their collections. The reference staff at the Center for Archival Collections were indispensable; in particular Marilyn Levinson and Stephen Charter. Lee and Bob McLaird were always available to share their scanning expertise. The local history staff at the Wood County District Public Library and the historical society were so accommodating, as was David Miller of the *Sentinel-Tribune*.

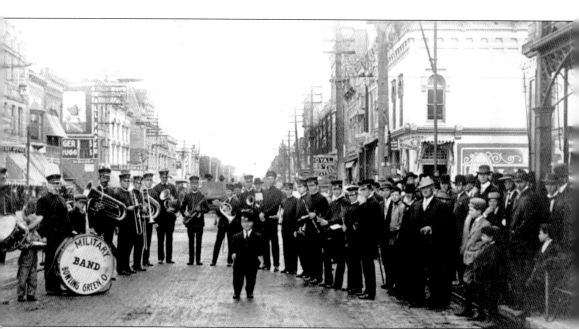

BOWLING GREEN MILITARY BAND DOWNTOWN c. 1913. (Courtesy the *Sentinel-Tribune*.)

INTRODUCTION

It seems reasonable to present the history of Bowling Green through a set of illustrated chapters that represent the city's various attributes: Black Swamp Settlement, Prosperous Wood County Seat, "Crystal City," Indomitable Enterprise—University Town, Mentor of Citizens, and Black Swamp Fun Spot to note just six.

Undeniably the history and development of Bowling Green, Ohio, has been shaped by its geography and certainly the tenacity and enterprise of its settlers, who began in 1833 recording the fact that they owned property in the Great Black Swamp. Undaunted by illness and threat of death from mosquito driven epidemics, these people endured and formed an incorporated village by 1855.

Second only to the swamp in notoriety around this area are the miles of mammoth ditches, which still immortalize those sturdy pioneers who began draining the swamp before the Civil War. They first cleared the timber from the land and then dug the ditches by hand. Their reward and the swamp's parting gift to the town was some of the richest farm land in this part of the country.

The story of Bowling Green gains momentum after it became the seat of Wood County government about 1870 and experienced substantial growth and economic prosperity. A downtown sprouted: schools, churches, and a town hall were built, and the railroad arrived once the county's affairs were relocated from Perrysburg. The County Infirmary was begun at this time, and its physical plant endures to this day as the home of the Wood County Historical Society, managed by the county commissioners and offering a full calendar of community events year round. The impressive 1896 Richardsonian Romanesque courthouse is still the jewel of the county and has recently had its exterior renovated and its matching jail and sheriff's residence converted into a records center and county law library.

In the mid 1880s the area's natural resources once again blessed Bowling Green with a gas and oil boom that further infused the community with an additional quantity of economic prosperity. Glass manufacturing, a bustling lumber industry, grain elevators, and flour mills sprouted. Architectural flowering reached full bloom in residential and commercial magnificence in the "Crystal City," especially in the wake of two major fires—one in 1887 and another in 1888 that severely damaged the downtown. Street paving, sidewalks, and major utilities arrived during the boom time.

By 1900 Bowling Green's population reached over 5,000, and the village was given a "city" designation the following year. Once the gas boom went bust and the prosperous glass industry crashed, the city leaders scrambled to find alternative sources of economic revenue for a city that was proving to be an indomitable enterprise. If the pioneers could drain that swamp their descendents could certainly reinvigorate the economy. In 1905 the Bowling Green Board of Trade was born, and by 1910 its auxiliary, the Bowling Green Commercial Club, arrived. Both would promote the city's commercial and economic advantages to prospective business and industrial enterprises interested in locating here. These efforts would merge into the Bowling

Green Chamber of Commerce in 1929. One important newcomer was the H.J. Heinz Company, enticed to Bowling Green in 1914 to develop a site formerly connected with the glass industry. This giant catsup plant remained a major city employer until 1975. Bowling Green would also attract the National Guard Armory and eventually such corporations as Cooper, Armco, and the Wall Street Journal distribution center.

The efforts of both the Commercial Club and other city promoters paid off in a big way in 1910 when Bowling Green was chosen to become a university town. The original city park grounds were selected as the future site of Bowling Green State University—then the Bowling Green State Normal College. Currently the university is the city's largest employer with 3,199 employees and 20,400 students currently enrolled. It has graduated such notables as Academy Award winning actress Eva Marie Saint, comedian Tim Conway, and Olympic gold medalist Dave Wottle. BGSU is the home of Buckeye Boys' State, attended by 500 young men every summer. The university has the only theater in the world named for motion picture star sisters Dorothy and Lillian Gish. The major performance theater is named for actress Eva Marie Saint, and a second theater bears the name of comedian Joe E. Brown, a northwest Ohio native.

Bowling Green has mentored its citizens with quality education, religious instruction, and service to community and country. One of our home grown stars is Olympic gold medalist Scott Hamilton. Another local success is former U.S. Congressman Delbert Latta, who served the district in Washington D.C. for 30 years. Bowling Green citizen and former Wood County Prosecutor, Betty Montgomery was Ohio's Attorney General and is now State Auditor.

Although the Black Swamp is gone from the landscape, it persists in the name of the community's drama troupe, The Black Swamp Players, and in the annual fall festival of the arts, The Black Swamp Arts Festival, a juried art show/sale with a music festival. The Black Swamp fun spot's yearly holiday parade through downtown draws participants and observers from around northwest Ohio when Santa comes to town. The National Championship Tractor Pulling Competition brings people from all over the U.S. to Bowling Green every August. New sidewalks, iron lamp posts, benches, and flower planters greet visitors as recent improvements in the historic business district. The 1926 Cla-Zel Theater, still a movie house, is being revitalized as a performing arts center, and the city's art galleries, shops, coffee houses, and unique restaurants

DOWNTOWN BOWLING GREEN WALL MURAL c. 1990. (Courtesy the author.)

One

BLACK SWAMP
SETTLEMENT
1833 TO 1867

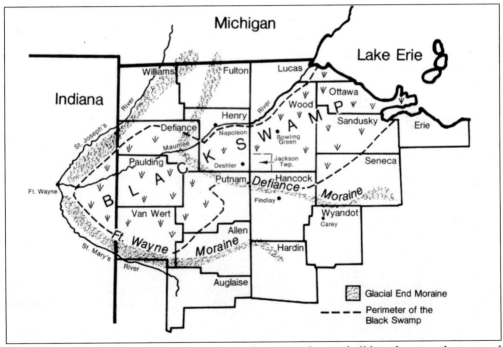

WET NORTHWESTERN OHIO. The Great Black Swamp deterred all but the most determined settlers from locating in northwest Ohio. The estimated 1,500-square-mile swamp ran parallel with the Maumee River's east bank and extended southwest from Lake Erie to New Haven, Indiana. Wood County was established in the heart of the swamp. By 1823 Perrysburg on the Maumee served as the county seat for almost 800 settlers. (Courtesy Lucas County-Maumee Valley Historical Society.)

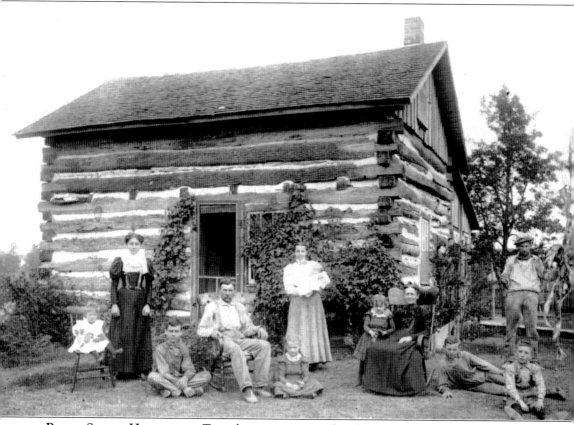

BLACK SWAMP HOMESTEAD. Townships were surveyed and named in the county, and settlers from mostly the mid-Atlantic and New England regions migrated through dense forest and damp ground beyond Perrysburg (next town south was Portage established in 1824) to build log and also stone dwellings upon dryer, glacier-produced sand hills and ridges. The Underwood family is pictured in front of their log homestead in Center Township south of Bowling Green about 1882. The early southern most portion of the community was called Mt. Ararat possibly because of the higher ground near the Perrysburg-Findlay Pike—today South Main Street and Napoleon Road. In 1835 this settlement was dominated by merchant Robert Mackie's business headquarters. The north end of the settlement was called Hannon's Corners, located near present day Poe Road and North Main Street. (Courtesy CAC-BGSU.)

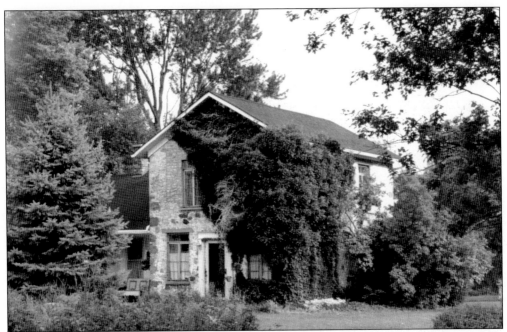

JAMES WATSON STONE HOUSE. In the vicinity of Mt. Ararat limestone dwellings were constructed among their log counterparts. One such Greek Revival-style farmhouse was built by James Watson on property he bought in 1834 along present day Napoleon Road. This is considered to be one of the earliest structures in Bowling Green and is still used as a private residence. In 1833 Elisha Martindale registered his land and was designated the first settler. Alfred Thurstin soon followed. (Courtesy the author.)

POST OFFICE NAMED BOWLING GREEN. In 1834 the Jacob Stouffer and Henry Walker cabin was built on a sand ridge at the northeast corner of North Main and Merry Streets. It became the first post office and Walker, first postmaster. Mail carrier Joseph Gordon of Kentucky named the post office Bowling Green after his favorite Kentucky town. The cabin now concealed at the rear of this home became the center of the town's early affairs. (Courtesy WCPL.)

11

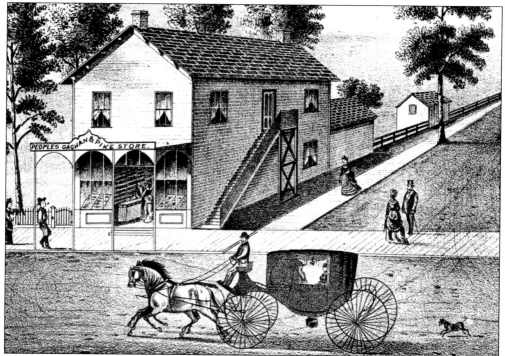

DAWN OF DOWNTOWN. A failed business venture near Mt. Ararat prompted early Bowling Green business man Levi C. Locke to locate his tavern and stock of goods north near the first post office. Alfred Thurstin, prosperous landholder, sold Locke ground on the east side of Bowling Green's South Main Street. Here he built a combined store and home. Downtown was born. Around 1848 the Gaghan and Pike general store opened at the corner of South Main and Union (Wooster) Streets. (Coutesy *1875 Wood County Atlas*.)

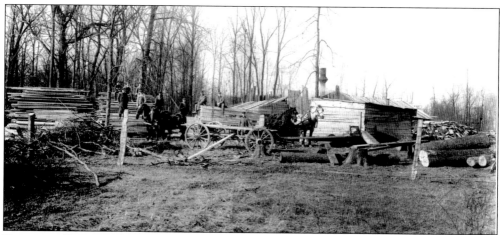

FAREWELL FORESTS; SO LONG SWAMP. Virgin forests towering over swamp made farming practically impossible in this part of Ohio. The trees would first have to be removed and the swamp drained. In 1859 the Ohio General Assembly passed a ditch law to assist citizens in draining their land. A timber crew cleared away the trees and brush once surveying and recording was completed for the course of a ditch. A flourishing lumber trade resulted and gained momentum once the railroad arrived. (Courtesy WCHS.)

PLANK MAIN STREET, 1855. Many of the felled trees were used for corduroy roads. One such road opened in 1853 running from Perrysburg south to Bowling Green—bringing more business to the village, which had incorporated in 1855. Main Street on this 1855 plat was then the Perrysburg-Findlay Plank Road—the principle north/south artery through the swamp linking Perrysburg with Portage to the south. The road closely followed General Hull's 1812 trail to Detroit. Such a quantity of timber accumulated with the land clearing that much of it was just stacked and burnt. Levi Locke is credited with starting the first factory in Bowling Green—an ashery in which oak timber would be burnt for the pot and pearl ash necessary to make soap and glass. (Courtesy CAC-BGSU, BG City Council Minutes.)

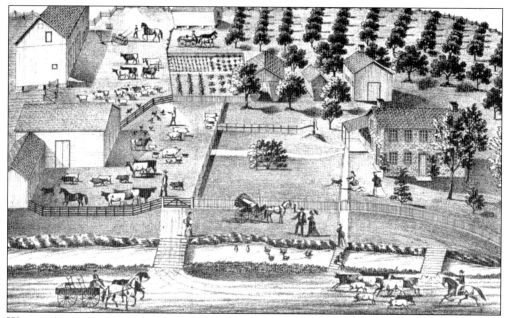

WATER AWAY EAST OF BOWLING GREEN. This drawing of the Caleb Root homestead in Troy Township from the *1875 Wood County Atlas*, features an 1824 stone house and impressive drainage ditches near the notorious "Mud Pike" (Route 20) through the swamp. Trees were cleared, stumps extracted, the ground prepared with a horse drawn plow, loose earth removed, and finally the packed earth and clay were dug out by hand to make the ditch. Loose dirt would be used for future road beds.

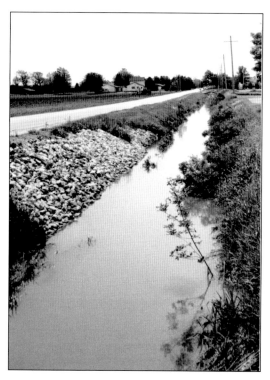

WATER AWAY ALONG LIBERTY HI. Over 15,000 miles of open ditches in northwest Ohio such as the one pictured west of Bowling Green, were mostly dug between 1870 and 1920, opening up millions of farmable acres. Over $100,000 was spent in the late 1870s digging the Jackson Cut-Off in southwestern Wood County. Approximately 30,000 acres worth of water were moved through this giant ditch and away from farm land. (Courtesy the author.)

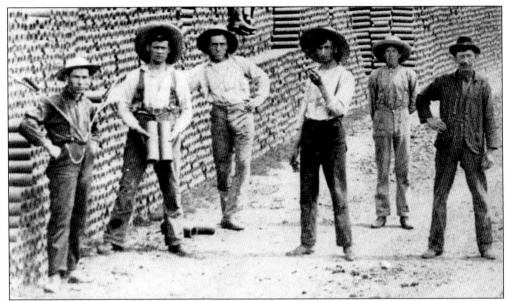

CLAY TILE MANUFACTURING IN PEMBERVILLE NEAR BOWLING GREEN. To truly defeat the swamp's standing water, farmers had to install underground piping systems that moved the water from the fields to the drainage ditches. Ironically the swamp harbored the seed of its own demise—impermeable clay for tile. A bustling drainage tile industry developed by 1870 in Wood, Henry, Paulding, and Putnam Counties. The extra timber was put to use in constructing the tile factories and fueling the early kilns. (Courtesy CAC-BGSU.)

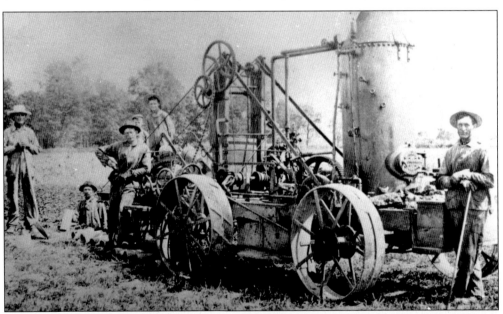

BUCKEYE TRACTION DITCHER. In the early 1890s Bowling Green resident James B. Hill built and patented a steam driven mechanical ditching wheel that spawned the future Buckeye Traction Ditcher Company. Forever after this tile draining of farmland was revolutionized. George and Harmon Sonnenberg are pictured here with their Buckeye Traction Ditcher in Hamler, Ohio, c. 1905. (Courtesy CAC-BGSU.)

KNAUSS FARM. German tenant farmers arrived in northwest Ohio late in the 1850s with very few resources except skill, discipline, and determination. They bought the undesirable swamp land at bargain prices, cut down the trees, drained the land, sold the lumber to hoop mills and stave factories among others, and used the profits to buy more property. George Knauss was such an immigrant who labored in similar fashion, becoming a prosperous land holder. His farmstead still stands just north of Bowling Green. (Courtesy *Picturesque Northwestern Ohio*.)

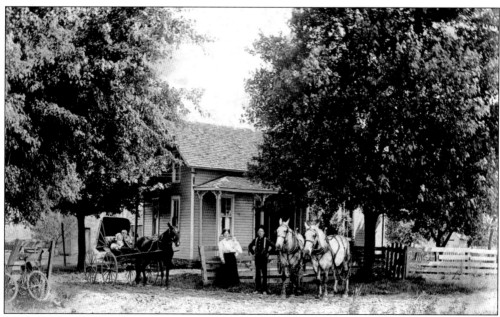

NEWLOVE FARM. This photo taken south of Bowling Green near Rudolph, Ohio, captures the Joseph Newlove family homestead *c*. 1900. (Courtesy J. Hiles.)

Two

Prosperous Wood County Seat
1868 to 1884

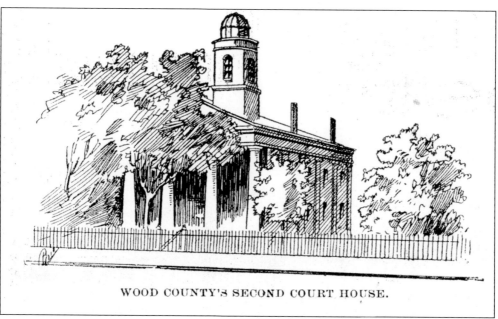

WOOD COUNTY'S SECOND COURT HOUSE.

PERRYSBURG, EARLY WOOD COUNTY SEAT. Organized in February 1820, Wood County was named for General William Henry Harrison's engineering officer at Fort Meigs—Colonel Eleazer Darby Wood. By 1823 Perrysburg was designated seat of the county's affairs with judicial and administrative jurisdiction over much of northwest Ohio and a portion of Michigan. A boundary dispute between the two states led in 1835 to the county's northern most boundary dropping back to the Maumee River. (Courtesy CAC-BGSU.)

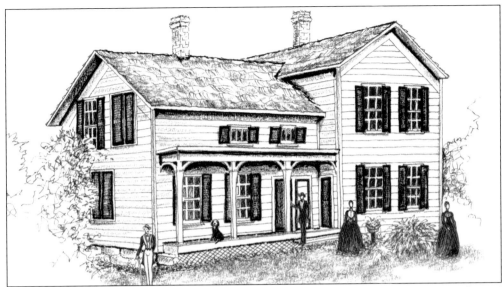

SPAFFORD HOMESTEAD IN NORTHWESTERN WOOD COUNTY. The more the swamp was drained the more the county prospered and its population expanded. Between 1850 and 1860 figures jumped from 9,157 to 17,886. By 1870 the number reached 24,596 and 34,022 ten years later. The *c.* 1853 Wood County home of William and Cora Spafford at Hull's Prarie near Perrysburg is portrayed here at the end of the nineteenth century. The family descended from early county landholder and first Wood County postmaster Major Amos Spafford. (Courtesy the author.)

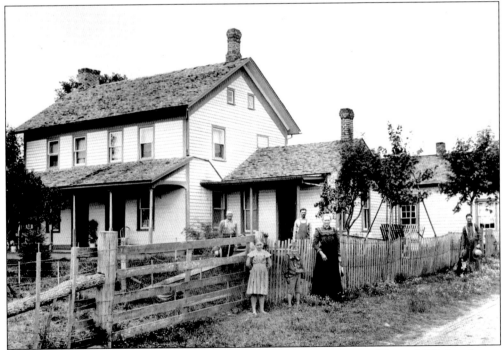

WILLIAM GRAHAM HOMESTEAD IN SOUTHEASTERN WOOD COUNTY. This *c.* 1850 farm house near Jerry City was photographed early in the twentieth century. Descendents of William Graham still occupy the home. (Courtesy CAC-BGSU, M. Reynolds.)

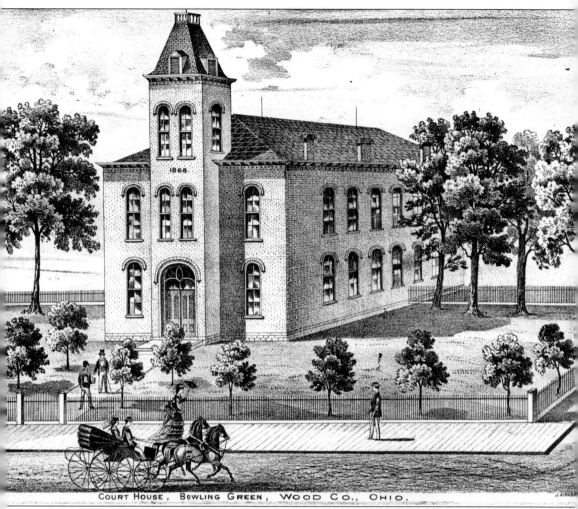

COURT HOUSE, BOWLING GREEN, WOOD CO., OHIO.

BOWLING GREEN, SEAT OF COUNTY GOVERNMENT, 1870. By 1866 a struggle commenced within the county between Perrysburg and Bowling Green over control of the county seat. Some of this contention was attributed to the settlers living in southern Wood County who dreaded crossing the swamp to get to Perrysburg to conduct business. By 1870 Bowing Green became the new county seat with almost 1,000 residents in the village. By 1880 the figure climbed to 1,539. A two story red brick courthouse was built with a three-story entrance tower on the corner of Summit and Court Streets. The structure cost an estimated $23,000 and faced Court Street. A jail was erected facing Summit. Virgin oaks and "fine" hickory trees adorned the single acre plot donated by early settler Alfred Thurstin. (Courtesy *1875 Wood County Atlas*.)

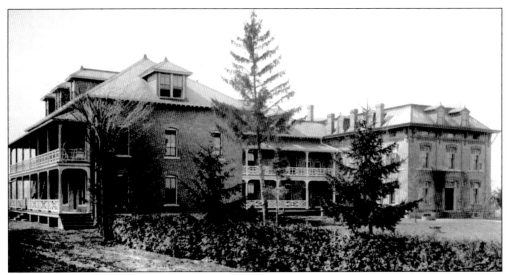

WOOD COUNTY INFIRMARY c. 1900. The 200-acre Adam Phillips farm said to be the oldest in Center Township was purchased for development as the county infirmary or poorhouse. Building began in 1868 on the west wing (right side). Around 1891 a center wing was added, and by 1898 an east wing would complete the four-story structure of 60 rooms. The brick facility was operated by the county commissioners who appointed a board of directors to set policy for the infirmary inmates: the ill, indigent, orphaned, and delinquent among the county's population. (Courtesy CAC-BGSU.)

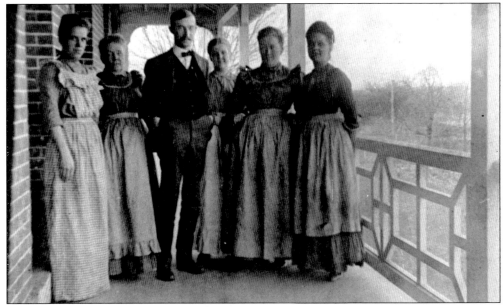

INFIRMARY EMPLOYEES AND THE SUPERINTENDENT. The infirmary's board appointed a superintendent, usually a married man, who with his wife lived on the premises and managed the daily affairs of the self-supporting farm with about 80 residents. Frank and Lottie Brandeberry were superintendent and matron of the facility for 45 years (1904–1949). Lottie was the daughter of Edwin and Charlotte Farmer (Charlotte is second on the left), who previously oversaw the infirmary's affairs from 1878 until 1904. (Courtesy CAC-BGSU.)

INFIRMARY FARM WORKERS. August Eschedor and Frank Russel are seen working the fields at the infirmary about 1908. (Courtesy CAC-BGSU.)

"LUNATIC HOUSE," 1885. Wood County's infirmary is among the last of Ohio's county poorhouses where most all of the original dwellings remain intact. It closed in 1971 and re-opened in 1975 as home of the Wood County Historical Society, Center, and Museum. The modest brick building in the photo standing near the east wing housed the mentally insane until 1900 when state law mandated that such citizens be sent to asylums. (Courtesy the author.)

BALTIMORE AND OHIO DEPOT IN BOWLING GREEN. The railroad in Bowling Green was integral to the county seat's prosperity and economic development. The Bowling Green Railroad Company, organized in 1874, linked with nearby Tontogany to connect into the Cincinnati, Hamilton, and Dayton Railroad. The resulting Tontogany and Bowling Green Railroad, with the village's first depot on North Grove Street, became part of the Baltimore and Ohio. Pictured here is the *c.* 1894 passenger depot at 521 West Wooster Street. (Courtesy WCPL.)

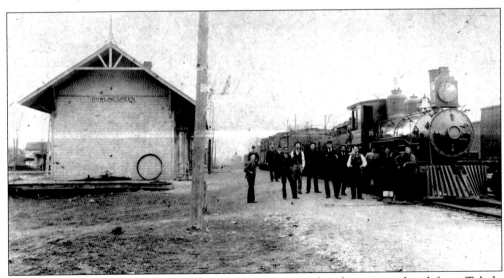

NEW YORK CENTRAL DEPOT c. 1880. By 1883 the railroad was completed from Toledo through Bowling Green to Findlay and would be reorganized in 1885 as the Toledo, Columbus, and Southern Railroad Company. This north-south road would become the Toledo-Columbus division of the New York Central. A late nineteenth century view of the depot on East Wooster is seen here. (Courtesy WCHS.)

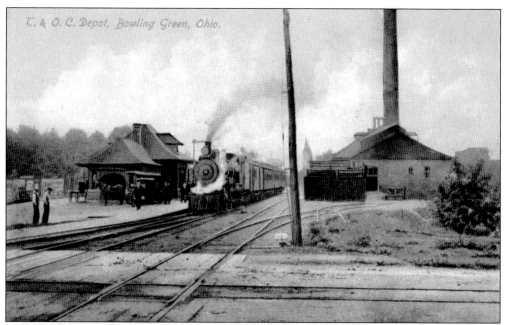

C. & O. C. Depot, Bowling Green, Ohio.

NEW YORK CENTRAL DEPOT c. 1903. This 1903 brick depot once stood on East Wooster and was razed in 1962. Local residents recall servicemen leaving for war from this depot. (Courtesy CAC-BGSU.)

HANKEY LUMBER COMPANY c. 1880. Increased population meant more building. In Bowling Green merchant tailor John R. Hankey purchased Amherst Ordway's 1859 grist/planing mill and lumber yard on South Prospect Street. The company was lauded as "one of the most extensive concerns in the line in the state, at the head of which is J.R. Hankey, who has done so much to build up the interests of Bowling Green." (Courtesy CAC-BGSU.)

SNOW FLAKE LIME COMPANY'S LIME KILNS. Lime kilns and quarries were a familiar sight in and around the growing county seat in the 1880s. Lime was integral to the building trade. George Hodgson, pictured second from right, operated a lime kiln in Bowling Green on Thurstin and East Court Streets near the present day BGSU heating plant along the railroad tracks. The quarry was near Wooster Street. (Courtesy CAC-BGSU.)

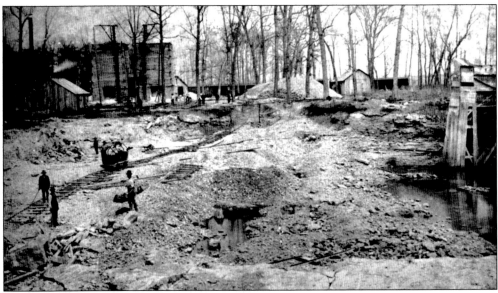

SNOW FLAKE LIME COMPANY'S PORTAGE QUARRY. This company had similar operations in Portage and apparently Sugar Ridge. The Portage lime kilns and quarry are pictured here in the 1880s. Early kilns were fueled with wood. By 1887 natural gas like the "magnesian limestone" was found in such great abundance that it replaced wood as fuel for the kilns. This was thought to produce a far superior quality of lime. Bowling Green at this time was considered to be blossoming into "the great lime producing center of the West," said the Bowling Green *Sentinel* on April 7, 1887. (Courtesy CAC-BGSU, D. Thiebaut.)

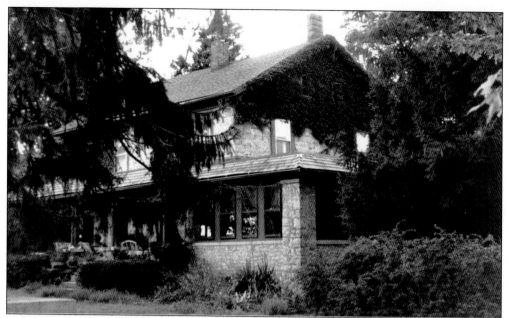

KLOPFENSTEIN LIMESTONE HOME. Early settler Peter Klopfenstein, son of French parents, was married in Wood County in 1837. He would settle in the Mt. Ararat area of Bowling Green and operate a quarry and lime burning business for over 25 years. His name is attached to a couple of fine "old rock houses" including this 1850s dwelling on Napoleon Road, which still serves as a private residence. Another of his stone dwellings is on South College Street near his quarry. That home is purported to have been a stop on the Underground Railroad. (Courtesy the author.)

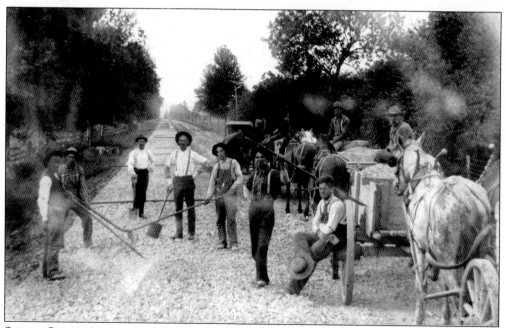

STONE CREW. A quarry on Clough Street was developed during the decade 1880 to 1890 specifically for stone needed to pave Wooster Street. Roads were tended by hand and horse as is evident in this photo taken in a rural Wood County setting. (Courtesy WCHS.)

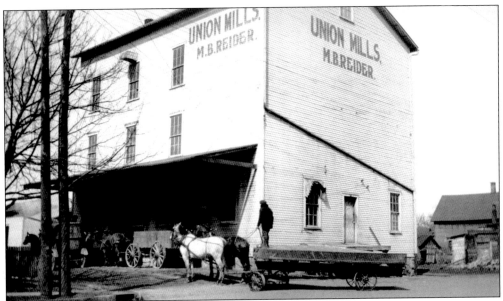

UNION MILL. By 1884 the Union Mill of Lewis Cramer and Morris B. Reider was located on North Grove Street south of the Bowling Green Railroad near the town's first depot (made famous during James G. Blaine's presidential campaign visit to Bowling Green late in the nineteenth century). Reider would buy out his partner by 1900. The building would be razed in 1953 to make way for B.G. Block and Lumber. (Courtesy CAC-BGSU, P. Schmitz.)

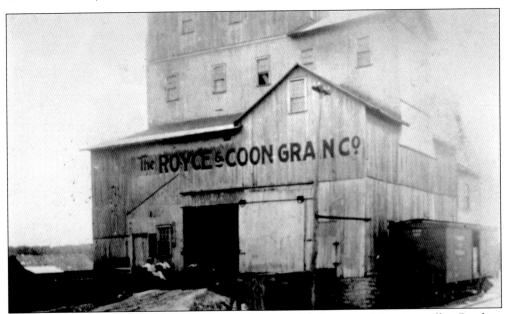

ROYCE AND COON MILL. By 1862 Ordway and Truesdale had a saw and flouring mill in Bowling Green. The local grain trade would, however, be invigorated by A.E. Royce, a Bowling Green grocery man turned grain merchant. He formed a partnership with J.J. Coon of Toledo. Royce and Coon flour and feed mills and elevators resulted. They had a North Grove Street location with two storage elevators near the railroad tracks south of Wooster Street and by 1893 a flour and feed mill on South Main Street. (Courtesy CAC-BGSU, D. Thiebaut.)

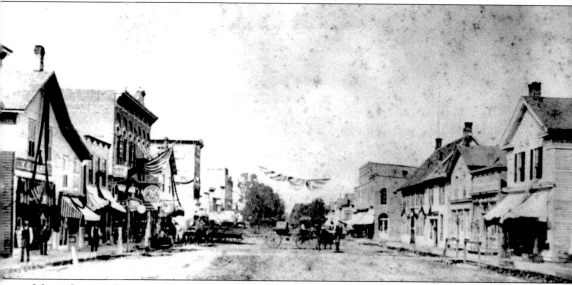

MAIN STREET LOOKING NORTH c. 1880. Less than a decade after Bowling Green became Wood County seat, the village was blossoming. Accompanying the newly arrived railroad and industrial development was a considerable expansion of businesses located in predominantly wooden frame structures along Main Street. It was noted by 1867 that the town could boast six dry goods merchants, five groceries, three millinery shops, two shoe stores, a barrel and tub factory, two wagon and carriage shops, two blacksmiths, two furniture rooms, three lumber yards, and a drug store. A few brick buildings are evident in this old photo. On the left, the tall building with the flag out front is the Union Block, 1877. The next tall brick building is the Exchange Bank c. 1880. Both still stand. The Lease House with its two chimneys is seen on the right side of the street almost across from the Union Block. (Courtesy CAC-BGSU.)

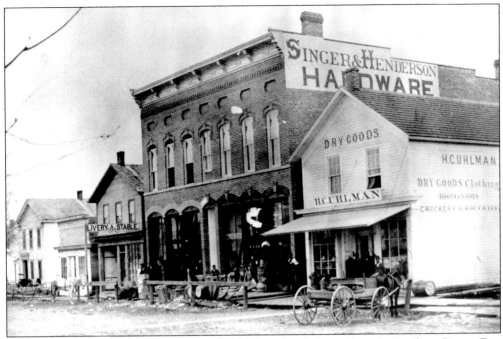

WESTON, OHIO, c. 1880. Many remember Uhlman's Clothing Store in Bowling Green. Few may realize that the family started out in the dry goods business in a town called Weston, northwest of Bowling Green. That prosperous community had the railroad earlier than Bowling Green and possibly had dreams of being in the county seat contest. (Courtesy CAC-BGSU.)

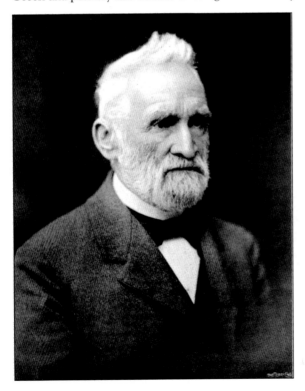

NORTON REED. This prominent businessman, "real-estate holder," and brother of Edwin Reed came to Bowling Green about 1865. The two men built the first brick block in town. Reed's "fine brick residence is an ornament to the city" mentioned Beers' Wood County History. He was a notable figure during the effort to remove the county seat from Perrysburg and in 1885 was listed among the stockholders of the BG Natural Gas Co. (Courtesy *Men of Northwestern Ohio*.)

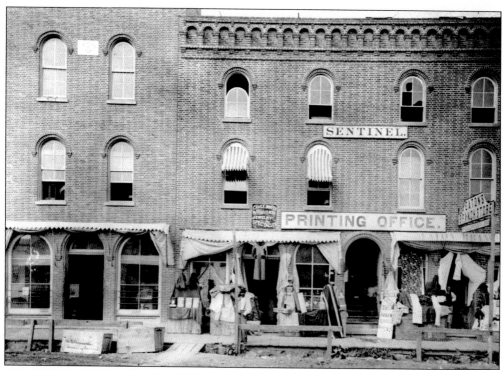

THE SENTINEL IN THE OLD REED BLOCK. The county seat dispute was chronicled in the pages of the town's early newspaper, the *Advocate*, a weekly formed in 1866 to secure the county seat for Bowling Green. The weekly *Sentinel* began printing in 1867 and in March 1868 located upstairs in the Reed, Rogers, and Manville Block. By the 1880s the newspaper resided in the 100 block of East Wooster Street. It would become a daily. By 1906 it had consolidated with the *Tribune* to become the *Sentinel-Tribune*. (Courtesy CAC-BGSU.)

ROGERS' DRUG STORE. This early Bowling Green business was founded in 1864 when Dr. T.J. Rogers and Dr. Andrew J. Manville opened a dry goods store in a frame structure. By 1867 they moved into the new brick Reed, Rogers, and Manville building on the west side of North Main Street. The drug store operated out of the three-story building appearing on the left in the photo. Pictured here is a remodeled version of the above 1867 building called the Broughton and Reed Block in 1889. (Courtesy CAC-BGSU.)

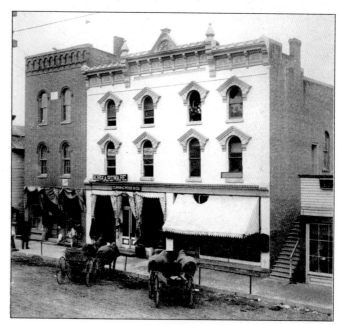

ROGERS BROTHERS' DRUG STORE. In 1866 Doctors Rogers and Manville were the town druggists. Doctor Rogers sold his interest in the business to Mr. Charles Rogers in February 1870. In 1891 his sons George and Clayton took over the store upon his death. George is pictured on the left and Clayton on the right flanking employee George Carmack *c.* 1920. The drug store remained open into the 1980s. (Courtesy CAC-BGSU.)

LINCOLN BLOCK. Alfred Thurstin built this Italianate-style building on the northeast corner of Main and Union (Wooster) Streets in 1874 as a general store. By 1889 the building was remodeled as a drug store for physician and druggist Doctor J.C. Lincoln and has remained the Lincoln Block ever since. (Courtesy the author.)

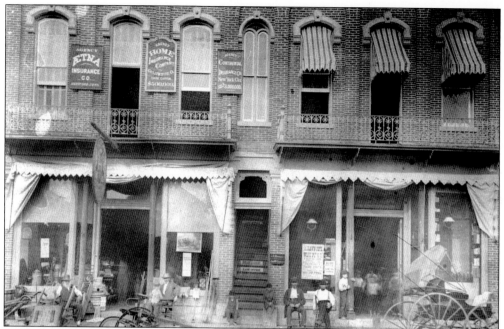

UNION BLOCK. In 1877 architect S.P. Stewart built the Italianate-style Union Block for Chris Lehmann, J.D. Bolles, and Dr. Andrew J. Manville. The Bolles and Manville Drug Store occupied the right store front (later Kiger's) and a hardware-implement business in the left. Later, about 1889, the building also housed Luther Black's Haberdashery, purchased from merchant tailor John R. Hankey. (Courtesy CAC-BGSU.)

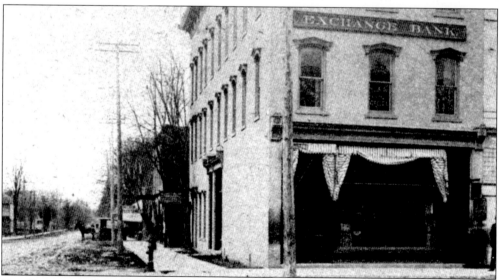

THE EXCHANGE BANK. Bowling Green's first bank, privately funded, was established in 1871. This Italianate-style structure was built by John R. Hankey in the early 1880s on the northwest corner of Main and Union (Wooster) Streets. Edwin Reed, Frank Beverstock, and Earl W. Merry were partners in the firm. John Hankey had a tailor shop on the second floor, the IOOF used the third floor as a lodge, and the town's early lending library also shared the building. (Courtesy Crystal City booklet.)

THE LEASE HOUSE. In 1854 George Thomas built a wooden tavern/inn on the southeast corner of Main and Union (Wooster) Streets. This lot remained devoted to public hostelry for years. Rod S. Lease purchased the property in 1870 from Isaac Clay, and the name was changed to the Lease House. The "town pump" was located at the Lease House corner. Later the business was operated by the Ross family as the Ross Hotel. The 1888 Bowling Green fire destroyed the building. (Courtesy the author.)

GILBERT Z. AVERY FAMILY c. 1885. G.Z. Avery of the hostelry and livery business operated the BG and Tontogany and the BG and Findlay stage coach lines. The Lease House, the American House (opened in 1869 on the corner of Liberty and North Main Streets), and the Russell House all offered livery services. G.Z. Avery, pictured seated in the center of the photo, signed the town's incorporation in 1855. He became first marshal and would own the Lease House, selling it in 1866 to Isaac Clay. (Courtesy CAC-BGSU, E. Elder.)

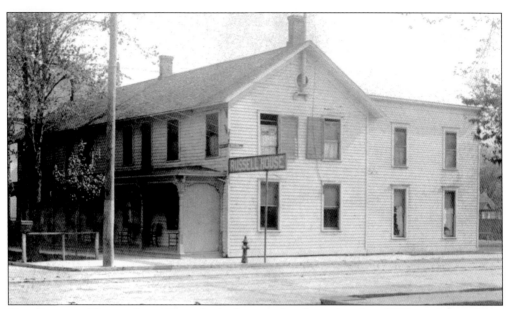

THE RUSSELL HOUSE. Larry Burns built this wooden frame hotel in 1870 on the southeast corner of North Prospect and Union (Wooster) Streets. Stable and livery services were provided. The hotel would be owned for a few years by one of the town's earliest landlords, George Thomas. Mr. and Mrs. Alfred Russell sold the business to Charles and Rebecca Ross in 1894, who would own it 74 years and through three generations. (Courtesy WCHS.)

THE UNION HOTEL. This quaint lunch room captures in its front window the reflection from across the street of the Union Hotel, a c. 1880 brick hotel owned by C.F. Button on Union Street behind the Exchange Bank. Its name would later become Hotel Wooster once the street name changed. (Courtesy CAC-BGSU.)

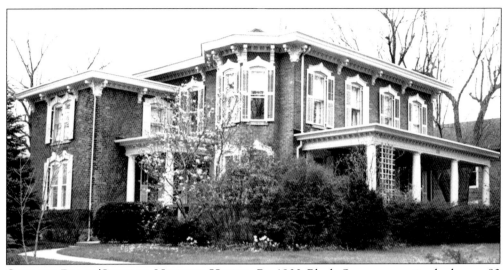

CAPTAIN BLACK/CAPTAIN NEWTON HOUSE. By 1900 Black Swamp counties had over 80 brick and tile mills. Bowling Green had its share. Not only were brick commercial buildings being erected, but brick residences as well. The *c.* 1878 Italianate-style house at 135 North Grove Street was owned by Captain Luther Black, former Civil War veteran and prosperous businessman. Later Captain J.B. Newton, also a Civil War veteran, would purchase the property. It was purported to have had the first bathtub in town. (Courtesy WCPL.)

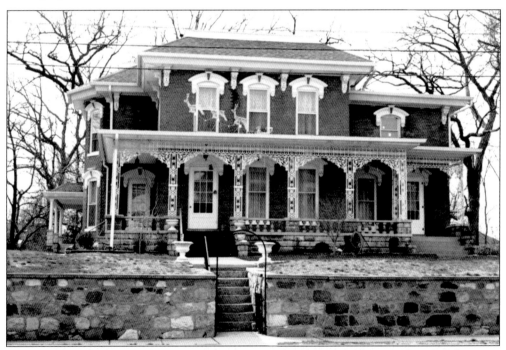

NORTON REED/BENJAMIN F. JAMES HOUSE. A close relation in style to the Black/Newton house is the Reed/James house, an 1877 Italianate residence at 305-307 North Church Street. Like its cousin, it was built high on a sand ridge. This home was built by prominent Bowling Green businessman Norton Reed and was later sold to attorney Benjamin James. Mrs. James held early meetings of the Shakespeare Round Table at the home. (Courtesy the author.)

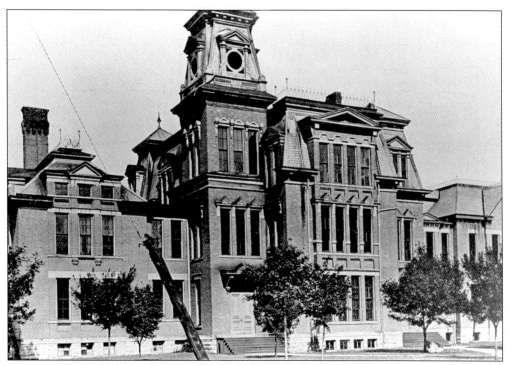

BOWLING GREEN'S BRICK SCHOOL HOUSE. The town's brick school building serving all grades was built on the site of the present school administration building on South Grove Street between 1879 and 1881. The three-story French Second Empire-style building would have two wings added in1891 to accommodate the oil boom population growth. The construction of the brick school was yet another example of the growing prosperity of the county seat. (Courtesy CAC-BGSU.)

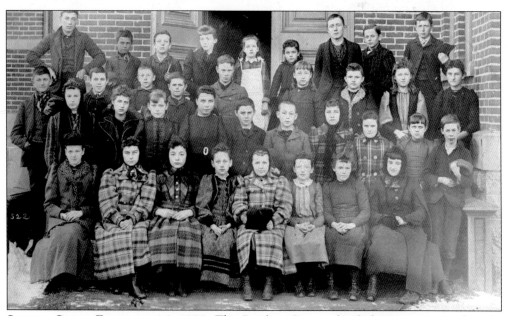

SCHOOL CLASS, FEBRUARY 16, 1892. This Bowling Green school photo was captured out in the cold on the steps leading into the building. (Courtesy CAC-BGSU.)

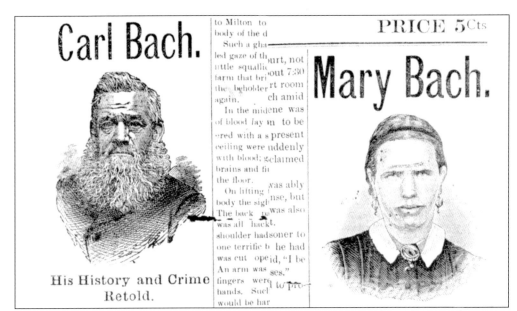

Carl Bach.

His History and Crime Retold.

PRICE 5Cts

Mary Bach.

to Milton to
body of the d
Such a gha
led gaze of th urt, not
uttle squallic
farm that bri out 7:30
the beholder rt room
again. ch amid
In the midene was
of blood lay in to be
ered with a s present
ceiling were uddenly
with blood; gclaimed
brains and fit
the floor. vas ably
On lifting
body the sigh nse, but
The back pa was also
was all hackt.
shoulder hadsoner to
one terrific b he had
was cut ope id, "I be
An arm was ses."
fingers were to pro
hands. Suel
would be har

CARL AND MARY BACH. These drawings of the Bachs appeared in the Wood County *Sentinel* during Carl's trial for murdering Mary, his wife, on October 19, 1881, at their home near Milton Center. Bach was found guilty of the slaying. His would be the last hanging in Wood County. October 12, 1883, Carl Bach was executed in the courthouse yard. The county fair was in town at that time. Twenty thousand people were said to have been in Bowling Green that day. (Courtesy WCHS.)

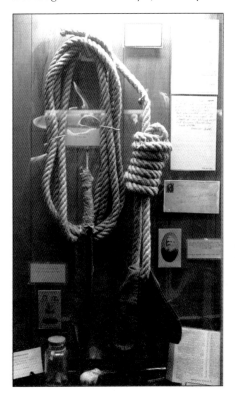

GRISLY MEMENTOS. Wood County Sheriff George Murray "Murr" Brown, who presided at Carl Bach's hanging, had in his possession the rope, black cap, or hood, and Mrs. Bach's fingers (crime evidence). Many generations of county school children vividly remember visiting the courthouse to see the fingers in a jar. Now these grim artifacts along with the corn-cutter murder weapon can be seen at the Wood County Historical Center. (Courtesy J.D. Pooley.)

Wood County Fair!

—TO BE HELD AT—

Bowling Green,

Oct. 5, 6, 7, 8, and 9, 1886.

OPEN TO ALL THE WORLD!

ALL PREMIUMS PAID IN FULL!

Prof. Jeakle's Pony Hippodrome,

WOOD COUNTY FAIR ADVERTISEMENT. In 1881 60 acres were bought from Charles and R.W. Gorrill by the Wood County Fair Association. This parcel, the future site of the Bowling Green City Park, faced Conneaut and Vine (Fairview) Streets. In 1885 the Fair Association and Agricultural Society agreed to sponsor a joint fair in town. It would be held at the current city park site until 1927. The fairgrounds were moved to the present day Poe Road location. Since 1851 there has been a Wood County Fair. It alternated between being held in Portage and Bowling Green. In 1861 until about 1885 Tontogany was home to the fair. (Courtesy CAC-BGSU.)

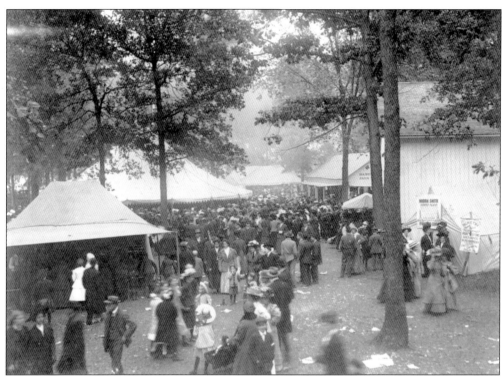

WOOD COUNTY FAIR MIDWAY c. 1900. (Courtesy WCHS.)

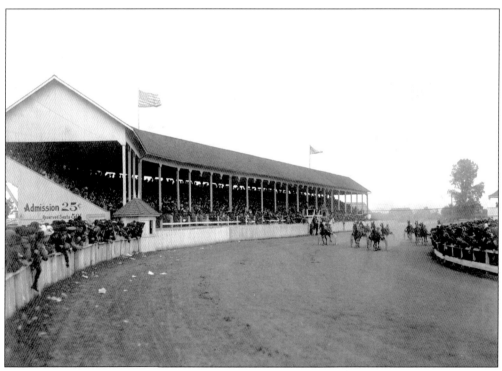

WOOD COUNTY FAIR RACE TRACK c. 1900. (Courtesy WCHS.)

Three

CRYSTAL CITY
1885 TO 1909

CANASTOTA GLASS FACTORY. Bowling Green's economic prospects crystalized around 1887 when a glass factory arrived to take advantage of the local gas boom and an accompanying promise of property. About 1885 a board of improvement was charged with developing industry in the town. Between 1887 and 1892 approximately half a dozen glass plants sprang up producing mostly window glass, jars, bottles, and some novelty and decorative glassware. Canastota blew window glass in northeast Bowling Green by the railroad tracks until 1889. (Courtesy CAC-BGSU.)

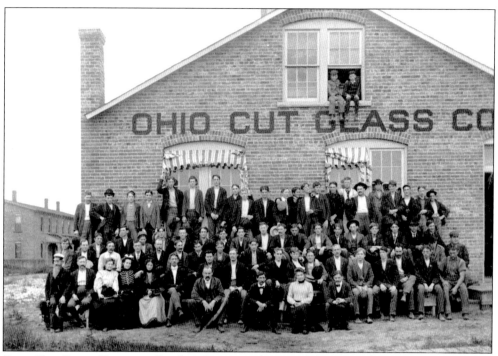

OHIO CUT GLASS COMPANY. Bowling Green was designated the "Crystal City" for the number of glass plants operating here during the gas boom. Once the boom subsided by the 1890s, a second glass industry developed specializing in cutting and decorating glass manufactured elsewhere. One such decorating plant was the Ohio Cut Glass Company, established in 1901 on North Enterprise Street near the Canastota site. It specialized in "expensive cutware" and was operating until about 1907. Its employees appear here in June 1902. (Courtesy CAC-BGSU, J. Terry.)

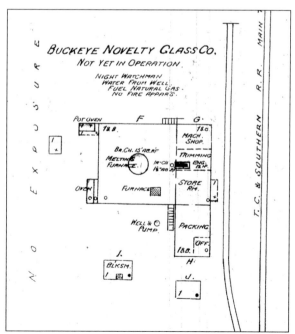

BUCKEYE NOVELTY GLASS COMPANY, JUNE 1888 SANBORN MAP. In August 1888 this glass plant opened west of the New York Central Railroad and south of Lehman Avenue. Edwin Reed and Captain Joseph Newton were involved in its operation. The company produced such items as flasks and lamps until the early 1890s. (Courtesy CAC-BGSU.)

CRYSTAL CITY GLASS COMPANY, MAY 1893 SANBORN MAP. This factory operated east of the tracks across from the Buckeye Novelty Glass Company. It opened mid year in 1888 specializing in Mason jars, flasks, bottles, and "druggist's sundries." By the early 1890s most of the Crystal City's gas boom had ended. This Lehman Avenue site, however, remained a prosperous, vital industrial property for many years to come. (Courtesy CAC-BGSU.)

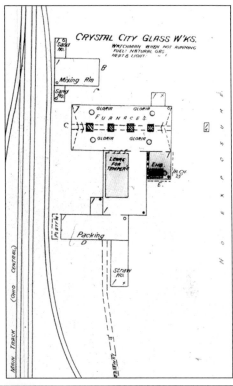

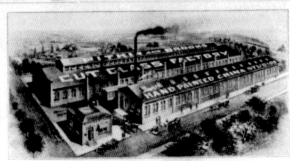

PITKIN AND BROOKS, INC. Chicago based ceramic and glassware distributor Pitkin and Brooks opened a glass cutting shop and china decorating studio in the former Ohio Cut Glass Company factory in 1908 on Enterprise Street. The company was destroyed by fire in 1912. This was the second major glass decorating company to come to Bowling Green during the city's second glass industry that developed on the heels of the gas boom. (Courtesy CAC-BGSU.)

EARL W. NEWTON. Earl's father, Civil War veteran, Captain Joseph B. Newton was affiliated with the Buckeye Novelty Glass, Ohio Cut Glass, and Ohio Flint Glass companies. Earl had worked at Ohio Flint. He started his own glass cutting business at 250 North Main Street in February 1918 and specialized in cutting blanks purchased from Libbey Glass. (Courtesy CAC-BGSU, J. Terry.)

For the Finest in Glass

The Earl W. Newton Co.

CONNEAUT AVENUE

* **Manufacturers of Fine Cut Rock Crystal Stemware and Tableware since 1921.**

* **Hand Painted Fired Colors on Tableware and Beverage Glasses, for Wholesale Only.**

EARL W. NEWTON, JR., Manager

ADVERTISEMENT FOR EARL W. NEWTON GLASS COMPANY. The company occupied a former broom factory on Conneaut Avenue in 1925. The Newton Glass Company added a line of mirrors and silver coated glassware. The business closed in 1955. (Courtesy *1947 BG City Directory*.)

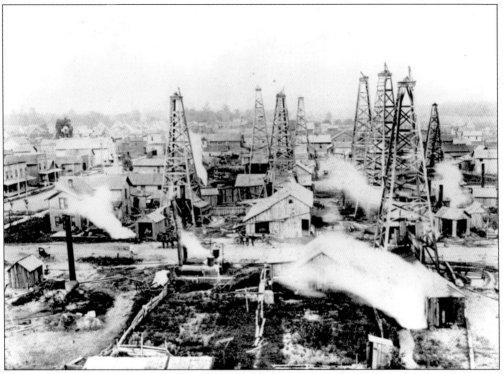

WOOD COUNTY OIL BOOM IN CYGNET. Not far behind the gas boom came the discovery of oil in Wood County late in 1886. Sucker Rod Field between Bowling Green and Haskins was notable for oil drilling. Land south of Haskins through Findlay to Lima was purported to contain one of the largest oil fields ever. Wood County was king in oil production in Ohio. Cygnet, a key oil town in southern Wood County, was dotted with derricks as seen here. (Courtesy WCHS.)

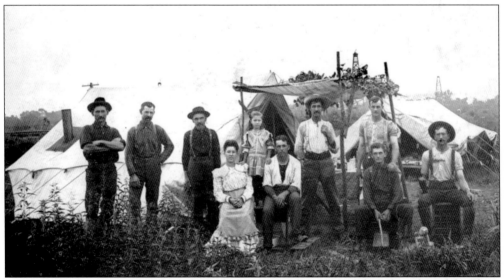

LIFE IN THE OIL FIELDS. Makeshift residences were often part of the oil worker's life. These men lived where they worked, attending to equipment round the clock. This photo was probably taken in southern Wood County early in the twentieth century. (Courtesy WCHS.)

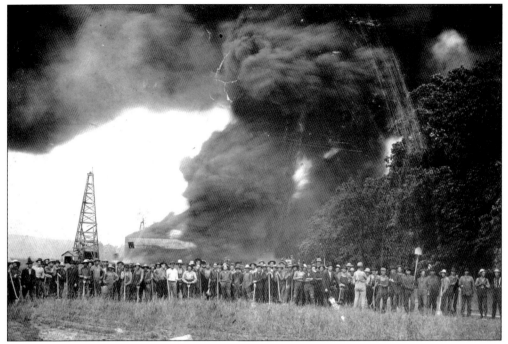

OIL TANK FIRE. Workers armed with shovels pose in this *c.*1900 photo as an oil tank fire rages behind them in Cygnet, southern Wood County's rich oil territory. It was noted that around 1887 10,000 barrels per day were produced in this part of the county. In the 1880s one third of the nation's crude oil was produced in Ohio—primarily northwestern Ohio. By 1896 over 5,000 oil wells were operating in the county. (Courtesy WCHS.)

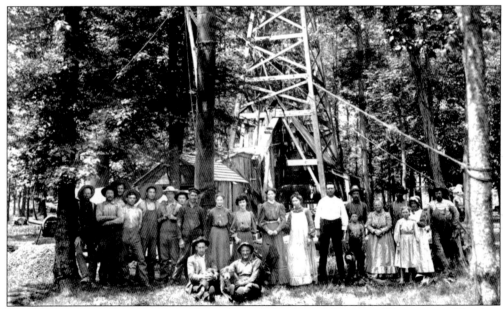

ANDERSON FARM. About 1890–91 oil was discovered in Prairie Depot, or Wayne, east of Bowling Green. The impact of oil would be felt for a number of years after as evidenced in this August 14, 1906, photo taken on the Anderson Farm on Caskie Road near Wayne. (Courtesy CAC-BGSU.)

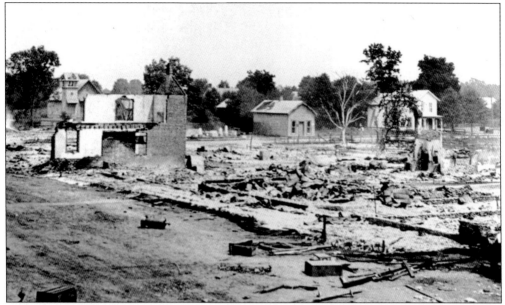

AUGUST 4, 1887, BOWLING GREEN'S "GREATEST FIRE" NEAR OAK STREET. In the midst of boom times' prosperity, the village's business district was hit by fire on a hot day in August 1887. The conflagration decimated a quarter of the downtown on the east side of Main Street from Thurstin's store north to Oak Street and back on Court Street. The heat even broke the plate glass windows of the Exchange Bank across Main Street. Damage was estimated at $40,000 with $17,250 worth insured. (Courtesy CAC-BGSU.)

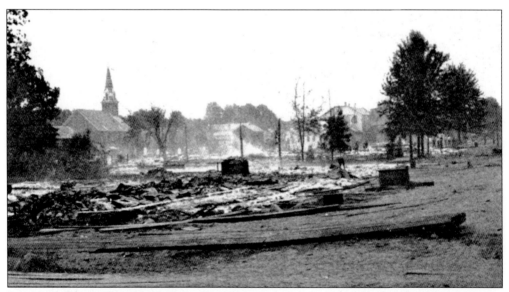

BOWLING GREEN FIRE NEAR EAST WOOSTER STREET. A second fire hit the Crystal City on October 31, 1888, starting mid block on the east side of South Main Street and spreading north to the corner of Main and East Wooster Streets. All told 18 businesses were lost including C.W. Evers' *Sentinel* Block, the C.C. Ross Hotel, and Mrs. James Smith's Opera House. Damages were estimated at $75,000 with $60,000 covered by insurance. Both fires were rumored to have started in a bakery. (Courtesy Crystal City booklet.)

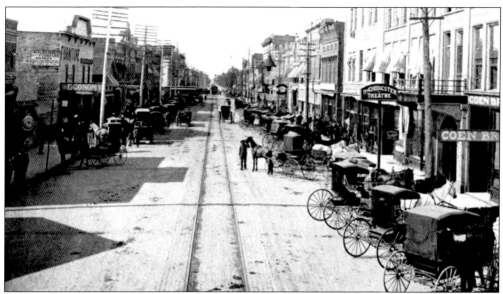

BOOM TOWN BOWLING GREEN c. 1906 ON SOUTH MAIN STREET LOOKING NORTH. The county seat was rebuilt on a grand scale after the fires and prospered. Between 1880 and 1890 the population climbed from 1,539 to over 3,467. Land prices soared, and hundreds of homes and businesses were constructed. Impressive brick and stone edifices replaced previous frame structures. Stone sidewalks were installed, and Main and Wooster Streets were macadamized. City lighting, waterworks, sewers, and other conveniences arrived. (Courtesy *1908 BG*, Walker.)

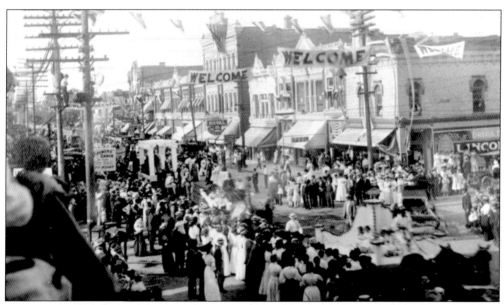

DOWNTOWN PARADE c. 1908 AT THE CORNER OF WOOSTER AND MAIN STREETS LOOKING NORTH. Fairgoers and firemen among others all found their way to downtown Bowling Green for a parade. The town's grand rebirth in brick buildings paid tribute to its enterprising businessmen as seen here along North Main Street behind the welcome banners. The Lincoln Building, the Eagle Block, the Thurstin Building, and the tall building anchoring the "new" Reed and Merry Block are an impressive backdrop for the festivities. (Courtesy CAC-BGSU.)

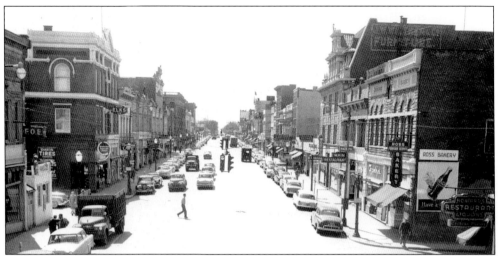

THE "NEW" REED AND MERRY BLOCK. The names Edwin Reed and Earl W. Merry are forever linked to the development of Bowling Green through such ventures as the first brick block in 1867, the 1871 Exchange Bank, the B.G. Natural Gas Company, and the Canastota Glass Works. In 1888 they constructed on the east side of North Main Street an impressive Queen Anne-style seven room brick block. It appears on the left side of this c. 1950 photo just past the Elks' sign. (Courtesy CAC-BGSU, B.G. Chamber of Commerce.)

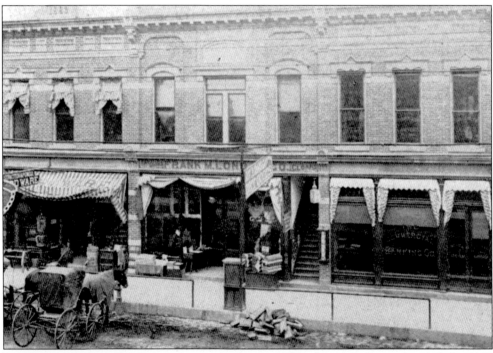

THE ROYCE BLOCK. Prosperous grocer, grain buyer, and banker, A.E. Royce founded the 1885 Commercial Bank (Royce, Smith, and Coon), the second financial institution in town. Royce built an impressive three-building block on the west side of South Main Street in 1889. Two thirds of the structure still stands minus the original bank building to the north. Oil was discovered on Royce property when drilling first began in the area. (Courtesy Crystal City booklet.)

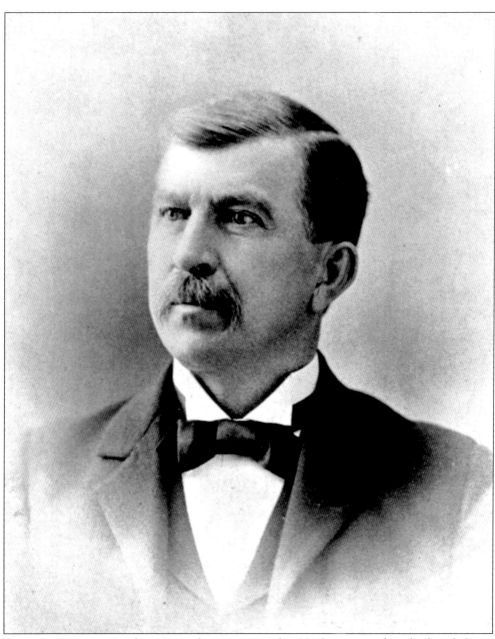

JOHN R. HANKEY. Bowling Green businessman John Hankey was truly a leading light in the Crystal City having seen the town's early days as a tailor/clothing merchant. About 1880 he entered the lumber and planing mill business just as the town burst with a great building demand. He built the Exchange Bank and the National Bank buildings, not to mention the Canastota Glass factory, and acquired wealth in the gas boom. In fact he and A.E. Royce were partners in a venture using natural gas for lime burning. They even built what was claimed to be the first natural gas lime kiln in Ohio. Hankey was founder and trustee of the B.G. Natural Gas Company and the Board of Improvement. He was also involved with such local glass factories as Lythgoe, Crystal City, and Buckeye Novelty and held substantial interest in the National Bank having been a co-founder. (Courtesy *Men of Northwestern Ohio.*)

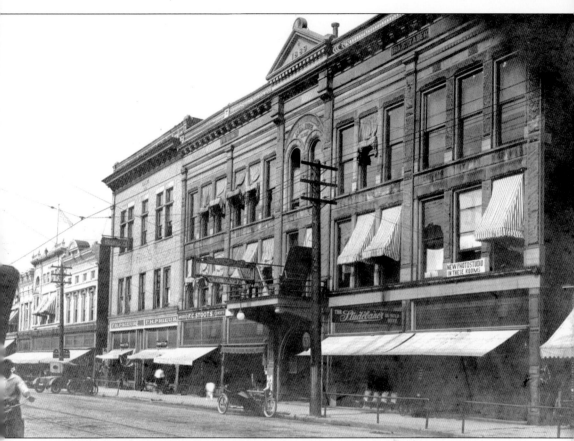

HANKEY-TABER OPERA HOUSE. The crowning tribute to John Hankey's success was possibly the $40,000 opera block he built on the east side of South Main Street. It served as the replacement for the old opera house block to the north destroyed in the 1888 fire. The new facility's imposing brick work was capably executed by notable Bowling Green brick contractor Morris Walker, who was also responsible for many of the town's early brick churches, banks, and business blocks starting in the late 1860s. Walker usually employed between 16 and 18 men. It was said that he finished the opera house job in about a month. The completed facility clamed to seat 1,500 in its "automatic opera chairs." Hankey's partner in the project, Ira C. Taber, was a local lawyer who had prospered in real estate and oil. In 1892 the Hankey Block was built just north of the opera house. It still stands having once housed Kauffman's Restaurant and is now Sam B's—another popular eatery. (Courtesy WCPL.)

THE FIRST NATIONAL BANK. This bank was constructed on the east side of South Main Street and opened in July 1889 as the only national bank in Wood County. Its board of Bowling Green businessmen read like a who's who of Bowling Green prosperity: J.R. Hankey, L. Black, S.L. Boughton, A. Froney, H.H. Clough, H.W. Morganthaler, and D.B. Beers. W.H. Millikin, Guy C. Nearing, R.S. Parker, L.C. Cole, and John W. Underwood would also be affiliated with the bank. (Courtesy *Sentinel-Tribune*.)

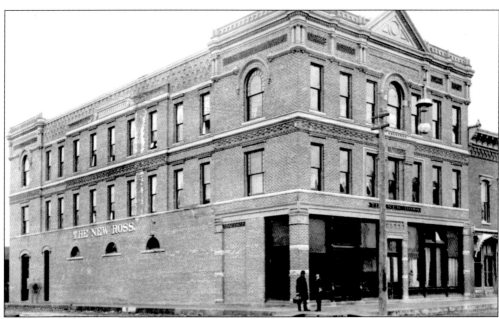

NEW ROSS HOTEL (HOTEL BROWN). After the 1888 fire destroyed the Ross Hotel on the Lease House corner, between 1889–1890, oil speculators "Murr" and Paul J. Brown and Charles Ross built the substantial three-story brick Queen Anne-style hotel on the southeast corner of Court and North Main Streets for approximately $19,000. S.P. Stewart was the contractor and builder of the 45-apartment facility. In 1892 it was sold and renamed Hotel Brown. Later it became the Elks Lodge. (Courtesy CAC-BGSU.)

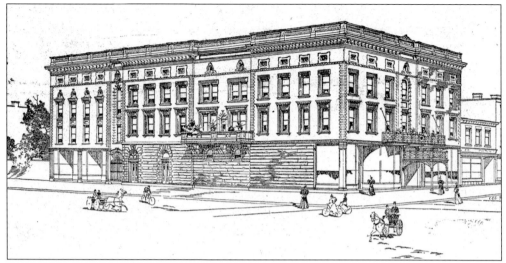

ARCHITECT'S RENDERING OF THE MILLIKIN HOTEL. Oilman W.H. Millikin came to Bowling Green and capitalized on the county's oil prosperity, giving the town its most sumptuous hotel with over 60 guest rooms. The three-story Second Renaissance-Revival-style hotel and business block were designed by the Toledo architectural firm of Bacon and Huber and built between 1895 and 1897 by contractor Richard Hattersley on the old Lease House corner for a cost of between $50 to $60,000. (Courtesy CAC-BGSU.)

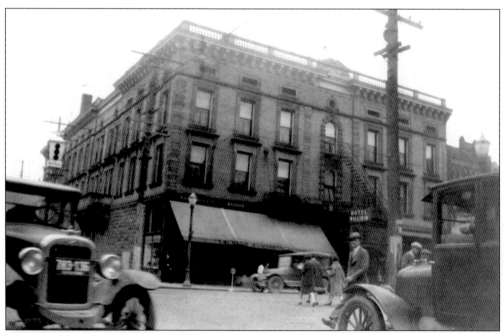

MILLIKIN HOTEL. Prominent visitors to the hotel were said to include hunters Clark Gable and Ernest Hemingway, Warren G. Harding, and H.J. Heinz. W.H. Millikin died in his apartment at the hotel on February 11, 1931. His daughter Grace married prominent department store owner Fred Uhlman. That Bowling Green department store was located for a time on the ground floor of the hotel. The Millikin remained open into the 1950s. The building was recently converted into apartments. (Courtesy CAC-BGSU, P. Schmitz.)

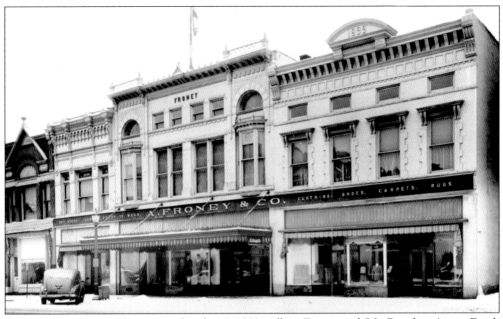

ALBERT FRONEY AND COMPANY. October 4, 1889, Albert Froney and S.L. Boughton's son, Frank H., opened a dry-goods establishment. From this would blossom A. Froney and Company on the east side of South Main Street near the site of L.C. Locke's store from approximately 40 years before. Froney was one of the town's wealthiest merchants, having started in business in Pemberville in the 1860s. He built the north room of his Bowling Green store in 1892. By 1895 a three-story double room materialized and later a final wing to the south. (Courtesy CAC-BGSU.)

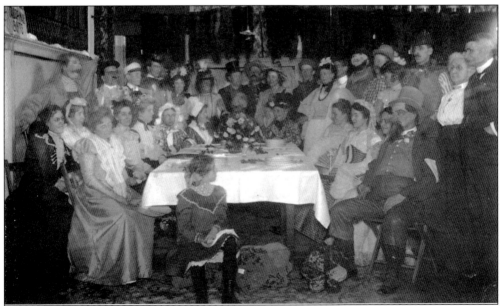

COSTUME PARTY AT FRONEY'S. In February 1903 Mr. And Mrs. B.J. Froney (son of A. Froney) hosted a rag time party on the second floor of the department store. He dressed as Rusticrube and she as Mrs. Katzenjammer. It was hailed "the funniest of all funny parties." B.J. Froney operated the store upon his father's death. (Courtesy WCPL.)

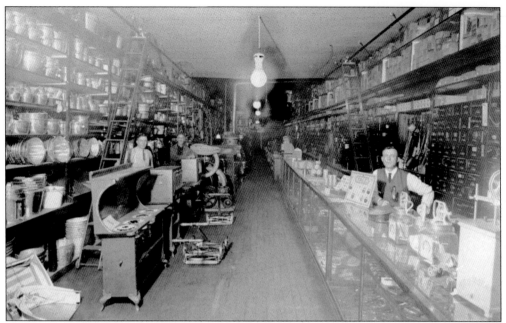

PRIEUR HARDWARE. F.H. Prieur's Hardware is pictured c.1910 at 185 South Main Street. (Courtesy WCHS.)

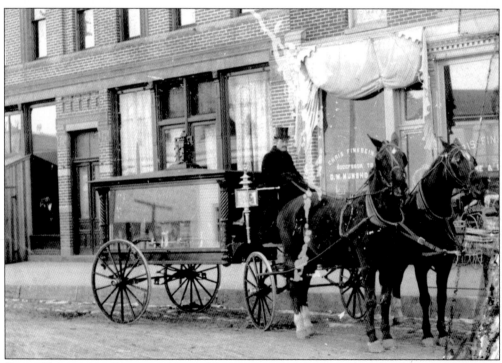

CHRIS FINKBEINER FURNITURE AND UNDERTAKING c. 1910. Chris Finkbeiner is shown in front of his furniture and undertaking business next door to the Hotel Brown on the east side of North Main Street near Court Street. Orme's Undertaking Parlor and livery service was located nearby on East Court Street. (Courtesy CAC-BGSU.)

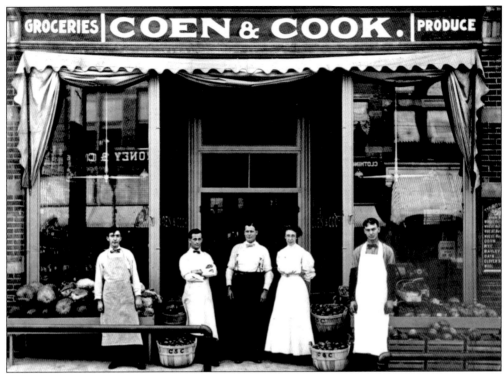

COEN AND COOK. This grocery and produce store was located on South Main Street across from A. Froney and Company. Horses could still be tied out front on the hitching rails visible in this *c.* 1900 photo. (Courtesy CAC-BGSU.)

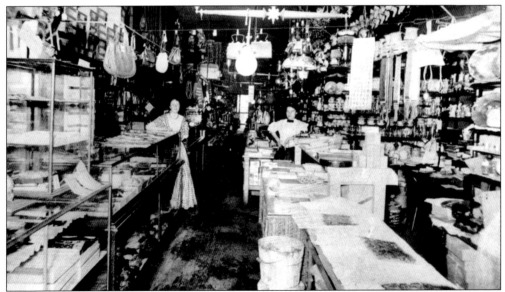

LADD AND ADAMS NOVELTY STORE *c.* 1909. This store at 127 South Main Street with an eclectic selection of merchandise was earlier called Noah's Ark and later became Henry Rappaport's Variety Store—"H. Rappaport and Company, For Everything." Belle Clayton appears at the left. (Courtesy CAC-BGSU.)

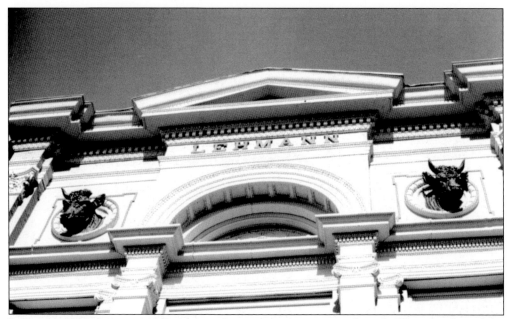

LEHMANN BUILDING c. 1896. Among the most unique, eye-catching buildings in downtown, standing on the west side of South Main Street next to the Union Block is Christoph Lehmann's Classical Revival building with two cow head sculptures protruding from the structure's ornate façade. Lehmann was a prominent businessman and butcher. Frank, Bill, and Jim Lehmann would continue to operate the Lehmann Brothers Market started by their father. (Courtesy the author.)

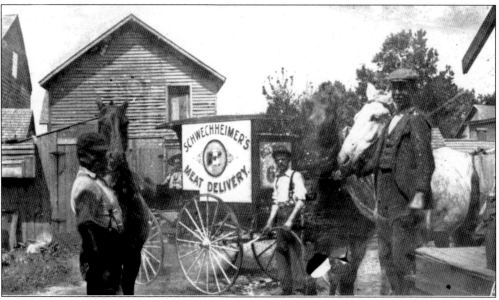

G. SCHWECHHEIMER'S MEAT MARKET. G. Schwechheimer was a half brother to Christoph Lehmann and went to work for him upon arriving in this country. By 1889 he opened his own market. Not only did he butcher his own meat, but he ran his own packing house as well. His business was located on South Main Street. (Courtesy CAC-BGSU.)

RAILROAD DEPOT INTERIOR. This photo with numerous calendars on display bears the date of April 21, 1911. It was said to be a Bowling Green depot interior. (Courtesy CAC-BGSU, E.Elder.)

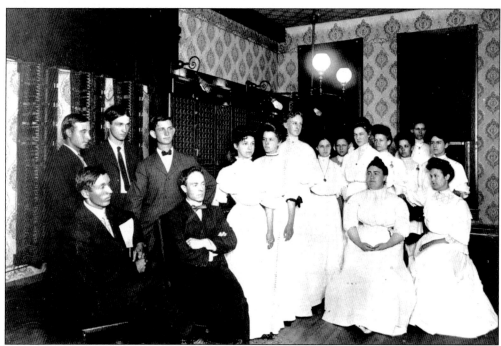

BOWLING GREEN CENTRAL UNION TELEPHONE OPERATING FORCE. In the 1890s Bell formed the Central Union Telephone Company in Bowling Green. An exchange was opened in the Whitehead Block on North Main Street: Sam Harvey was the manger for about 11 years and Nell Repass chief operator for about 12 years. Seated left to right in this 1902 photo are Samuel C. Harvey, possibly Gary Chamberlin, Nell Repass, and Bess Star. (Courtesy CAC-BGSU.)

BOWLING GREEN CITY BUILDING.
Reflective of the downtown prosperity
was the construction of an inspiring
brick Romanesque-style town hall with
tower and open belfry in 1892–1893
at the end of the West Wooster Street
business district. David L. Stine, a
Toledo architect, designed the $30,000
structure. Between 1894 and 1896 it
served as the county courthouse while
the present courthouse was under
construction. City offices moved to the
former Church Street School/public
library building in 1976. (Courtesy *1908
BG*, Walker.)

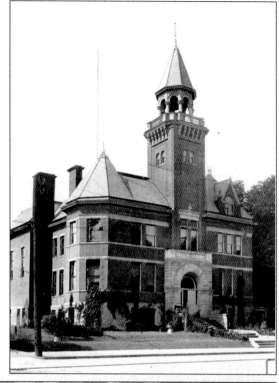

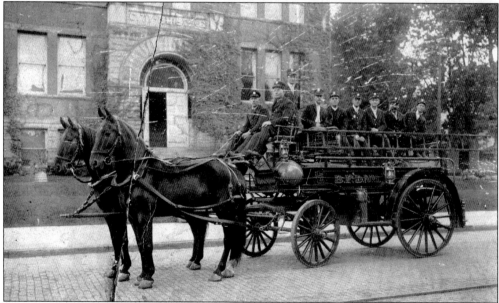

FIREMEN IN FRONT OF THE CITY BUILDING c. 1900. The city building was home to the
Bowling Green fire and police departments. Once the fire department built a separate
firehouse on the corner of Thurstin and Court Streets; only the police department remained
at the town hall. The building was renovated in 1984–1985. The original walls were retained
on the north and west sides including the three bays facing Church Street. The interior was
completely updated. (Courtesy WCHS.)

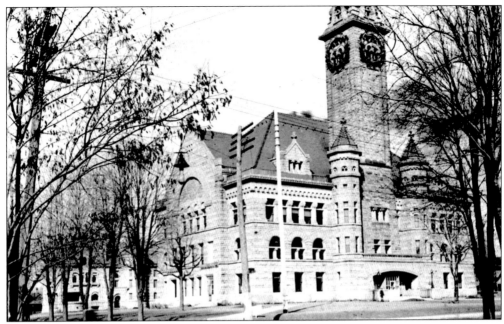

WOOD COUNTY COURTHOUSE. By 1896 the Wood County seat had a new sandstone and granite courthouse, which was the epitome of oil boom splendor. The earlier brick courthouse had been demolished in 1893. In 1894 the cornerstone had been laid for the impressive Richardsonian Romanesque fortress with elaborate stone carving. The cost was estimated at $256,000. The soaring 195-foot tower is noted for its clock hands that reach 16 feet across—at the time the second largest of their kind in the United States. (Courtesy WCHS.)

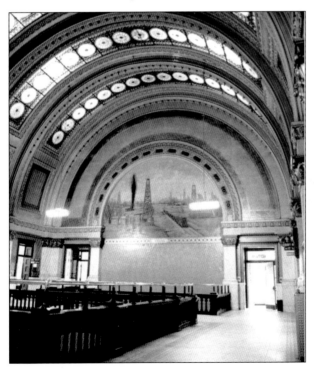

COURTHOUSE MURAL OF THE OIL FIELDS. The building's lavishness is echoed throughout its interior especially on the third floor where stained glass, elaborate moldings, and decorative elements prevail. Two murals are especially notable. One of these depicts the southern Wood County oil fields and the other, Fort Meigs near Perrysburg painted by Bowling Green Mayor I.M. Taylor. (Courtesy CAC-BGSU.)

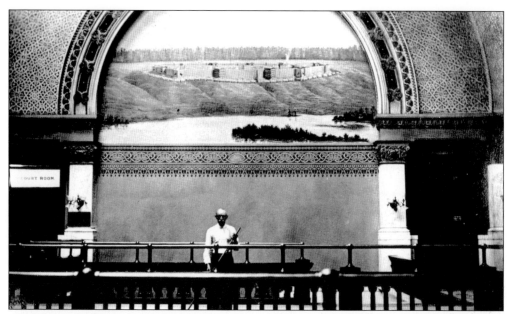

COURTHOUSE MURAL OF FORT MEIGS. Jimmy Hughes is seen posed beneath the I.M. Taylor mural of Fort Meigs on the third floor of the courthouse. The county eventually outgrew these opulent facilities. Between 1975 and 1977 a five-story Wood County office building was built north of the courthouse to help relieve the overcrowding. Various restorations of the courthouse have occurred since the late 1970s. Most recently its exterior stone work underwent major rehabilitation. (Courtesy WCHS, T. Weaver.)

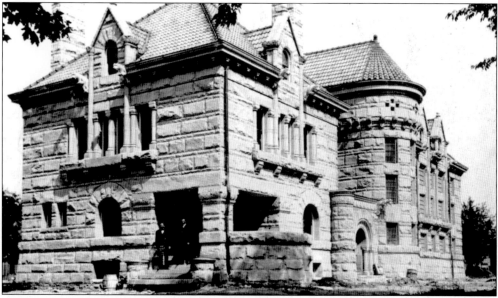

WOOD COUNTY JAIL AND SHERIFF'S RESIDENCE. A smaller "fortress" was constructed northwest of the courthouse to serve as the county jail and sheriff's residence. Becker and Hitchcock, Toledo architects, designed the structure, which was finished in about 1902 for an estimated $50,000. Recently the building was gutted and converted into an impressive records center and law library for the county. (Courtesy CAC-BGSU.)

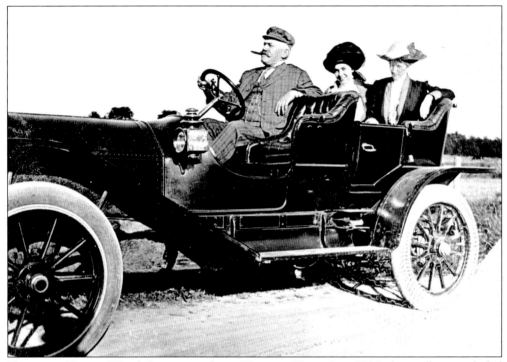

TAKING A DRIVE. Wood County employee Toinette Weaver's *c.* 1913 photo album included such snap shots as this image of Judge F.A. Baldwin, herself, and Julia Cramer out for a spin. (Courtesy WCHS, T. Weaver.)

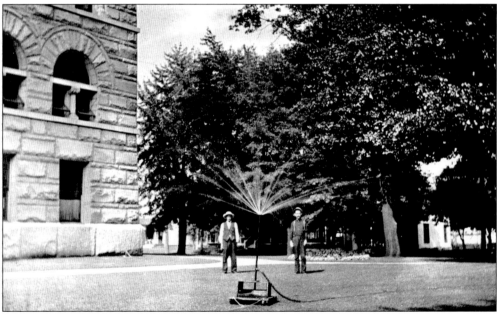

WATERING THE GRASS. Jimmy Hughes and Mr. Finch were photographed with the sprinkler on the courthouse lawn. They ended up in Toinette's album.(Courtesy WCHS, T. Weaver.)

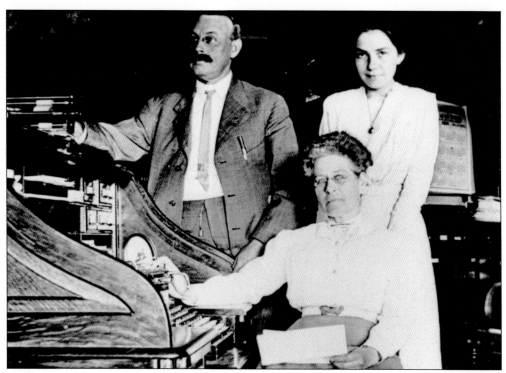

WOOD COUNTY CLERK OF COURT'S OFFICE. Toinette Weaver is seen with E.L. Blue and Alta Dekiar (seated). (Courtesy WCHS, T. Weaver.)

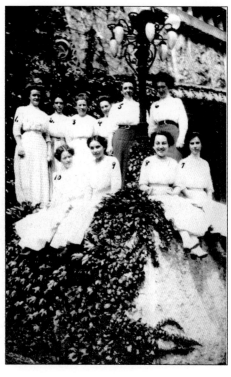

COURTHOUSE "BUNCH." Pictured at the front entrance to the Wood County courthouse from left to right are: (front row) Mayme Kehler, Toinette Weaver, Hazel Crane, and Irene Winton; (back row) Mrs. Ralph Gillespie, Ada Badette Stinebaugh, Alta Dekiar, Helen Canary, Miriam Dunn, and Julia Cromer. (Courtesy WCHS, T. Weaver.)

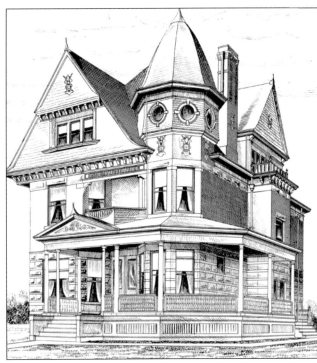

THE HANKEY HOUSE. Not only was there an architectural flowering in commercial and public buildings in boomtown Bowling Green, but residential splendor reached its apogee especially on West Wooster Street where the town's affluent oil boom citizens settled. Around 1987 approximately 95 homes in this neighborhood were accepted for the National Register. Included was the *c.* 1890 Queen Anne-style home of businessman John Hankey at 408 West Wooster Street. (Courtesy Crystal City booklet.)

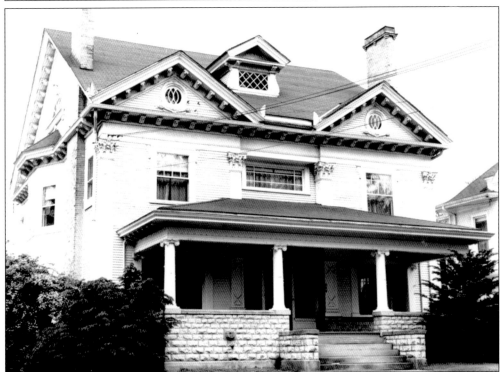

THE HICKOX-MOORE HOUSE. This fine home with Georgian-Classical Revival styling was built around 1902 at 324 West Wooster Street by banker J. Hickox. It was later owned by F. Moore of the A. Froney Company. (Courtesy WCPL.)

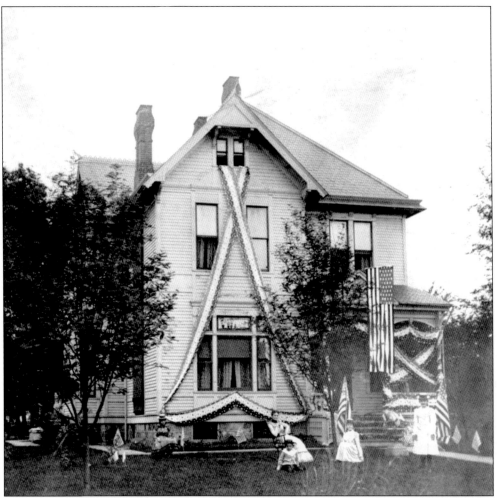

THE FRONEY-UHLMAN HOUSE. This stately Queen Anne-style home at 307 West Wooster Street dressed in patriotic splendor was built about 1888 by Albert Froney, a noted Bowling Green dry goods merchant. In 1896 it was purchased by oil man William Millikin, whose name is attached to the palatial downtown hotel of the same name. Through the marriage of William's daughter Grace to Fred Uhlman, a clothing store proprietor, the home achieved the distinction of having been owned by two of Bowling Green's most prominent department store families. The Uhlman-Millikin descendents still own the home. (Courtesy CAC-BGSU.)

THE CONLEY HOUSE. Thomas F. Conley, Bowling Green attorney, one time mayor, Wood County's first official court reporter, and manager of the grand Chidester Theater, lived with his wife and their daughter Minniebelle at 403 West Wooster Street. Minniebelle was for many years the society editor at the *Sentinel-Tribune*. She remained a fixture of the community until her death in 1984. (Courtesy the author.)

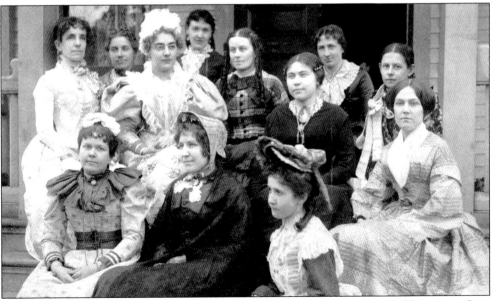

SWEET SIXTEEN CLUB COSTUME PARTY. This 1896 costume party was attended by women from some of Bowling Green's notable families: Case, Eberly, Hankey, Munshower, Ross, Lincoln, and Royce to name a few. Mrs. Thomas F. Conley is pictured at center in spectacles wearing a frilly cap and puffy sleeved costume. (Courtesy CAC-BGSU, WCPL, M. Conley.)

MOTHER AND DAUGHTER CONLEY. Mrs. Thomas F. Conley holds her daughter Minniebelle in this photo taken by Bowling Green photographer James A. Walker, April 2, 1899. Walker's Studio was located on the second floor of the Royce building. (Courtesy CAC-BGSU, M. Conley.)

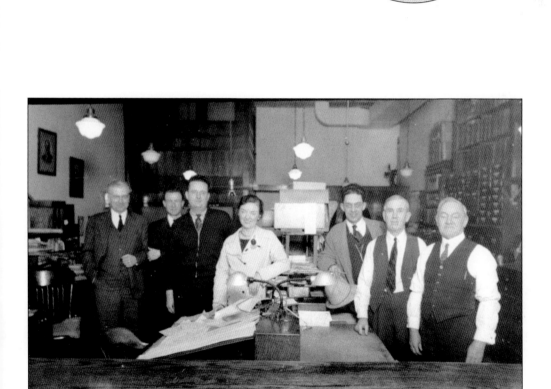

STAFF OF THE DAILY *SENTINEL-TRIBUNE*. The news and advertising staff of the *Sentinel-Tribune* are pictured here in a late 1920s photo. Society Editor Minniebelle Conley is pictured at the center. She is surrounded from left to right by Claude M. Haswell, owner and manager; Larry Newman, reporter; Fermont Fluhart, circulation manager; Paul Fuller and Jap Taylor, advertising; and George Katzenmeyer, bookkeeper. (Courtesy WCPL, M. Conley.)

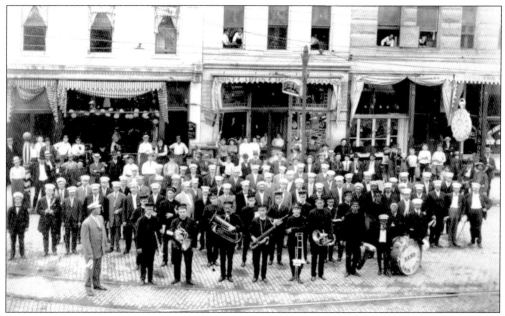

CITY OF BOWLING GREEN. By 1901, with a population exceeding 5,000, Bowling Green achieved city status. About a decade earlier natural gas heating and lights; electric lighting; telephone service; and water works had truly modernized the town. The Bowling Green Military Band is seen in this photo downtown *c.* 1910 in front of the Exchange Bank on the interurban tracks before a trip to Wapakoneta, Ohio. (Courtesy CAC-BGSU.)

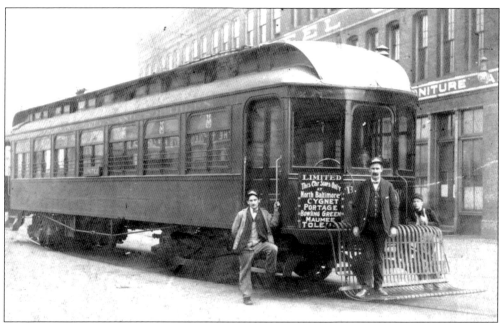

TROLLEY TIMES. The Toledo, Bowling Green, and Southern Traction Company's first car from Perrysburg arrived in the city in September 1902. Cars on the line ran from Toledo to Findlay by 1906. The tracks came right down Main Street to points further south. (Courtesy WCHS.)

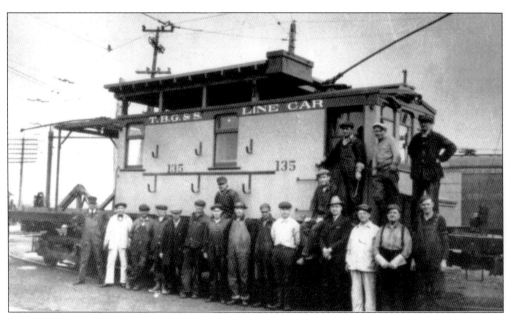

THE TOLEDO, BOWLING GREEN, AND SOUTHERN LINE CAR. The company's line car and workers are pictured at the car barns on south Main Street in Bowling Green. The barns now house a furniture store. (Courtesy WCPL.)

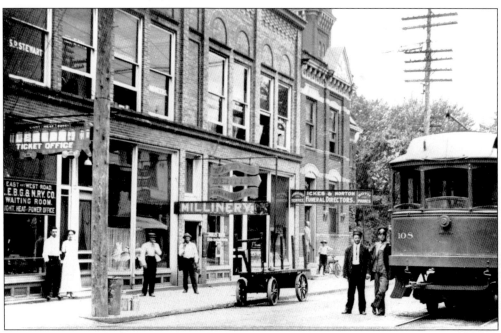

THE LAKE ERIE, BOWLING GREEN, AND NAPOLEON. This east and west electric road was completed between Bowling Green and Pemberville and put into operation by Thanksgiving 1902. Next a connection between Pemberville and Woodville and later Bowling Green and Tontogany were made. An interurban car can be seen stopped at the company office on West Wooster Street in Bowling Green. The tower of the town hall peaks above the roof of the last building on the left. (Courtesy CAC-BGSU.)

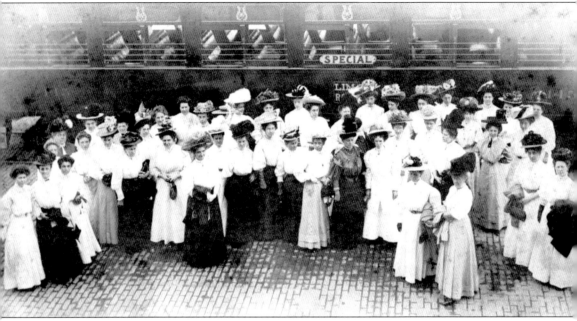

LADIES' INTERURBAN EXCURSION. Among the ladies pictured in the *c.* 1904 photo during a trip on the interurban are Mrs. Albert Froney, Mrs. Thomas Conley, Mrs. Earl Merry, and Cora Purdy (aunt of author James Purdy). (Courtesy CAC-BGSU, M. Conley.)

Four

INDOMITABLE ENTERPRISE—
UNIVERSITY TOWN
1910 TO PRESENT

IVY HALL. By 1904 the city's population of over 5,000 dropped to around 4,700 as oil speculators moved on. In 1905 the BG Board of Trade materialized, and again financial inducements were offered to businesses who would move here. Symbolic of this was Ivy Hall, which once stood on East Wooster and Thurstin Streets. Over the years it had housed the Lefevre Arms Company, a glove factory, the Monarch Underwear Company, a hatchery, and finally a student dorm. (Courtesy CAC-BGSU.)

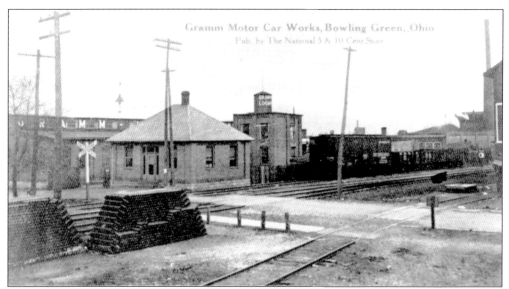

GRAMM-LOGAN MOTOR COMPANY. Lehman Avenue's proximity to the railroad tracks on the southeast side of Bowling Green made it the perfect location for industrial development starting in earnest with the glass companies. The Leonard Stove and Range Company, home of the "Ideal Star" steel range (1905–1908) would be replaced by Gramm-Logan (1908–1910), which briefly manufactured trucks, taxis, and automobiles. It relocated to Lima, Ohio, and was replaced by the Bowling Green Motor Car Company. (Courtesy CAC-BGSU.)

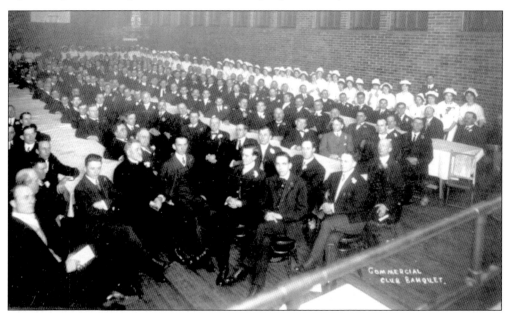

BOWLING GREEN COMMERCIAL CLUB. By 1910 the population was over 5,200, and the auxiliary to the BG Board of Trade, the Commercial Club, was recruiting more committed business interests to the city. Among these were a normal college, or teachers' school, known today as Bowling Green State University and the National Guard Armory secured in 1910. The H.J. Heinz Company arrived in 1914, and a palatial stone-faced post office was built much to the credit of the Commercial Club. (Courtesy CAC-BGSU, BG Chamber of Commerce.)

CITY PARK GROUNDS. The 10-acre city park and 73 additional acres east of Bowling Green were donated in 1913 for the development of Bowling Green State University. (Courtesy *1908 BG*, Walker.)

OHIO NATIONAL GUARD ARMORY. Due largely to the efforts of the Commercial Club, the city became the site of the Ohio National Guard Armory in 1914. The building was utilized for the first Bowling Green State Normal College classes while campus was under construction. The school's library was located across the street from the armory in the basement of the Methodist Church. (Courtesy WCHS.)

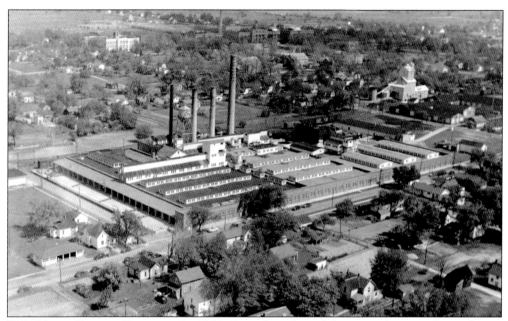

H.J. HEINZ CATSUP FACTORY. In 1914, from the ashes of the once thriving glass industry, arose a new era of economic prosperity for Bowling Green when the Commercial Club secured the Heinz plant. The factory was built on property formerly occupied by the Ohio Cut Glass Company. In this *c.* 1940 photo, Bowling Green State University is visible in the background near the single smoke stack. (Courtesy CAC-BGSU.)

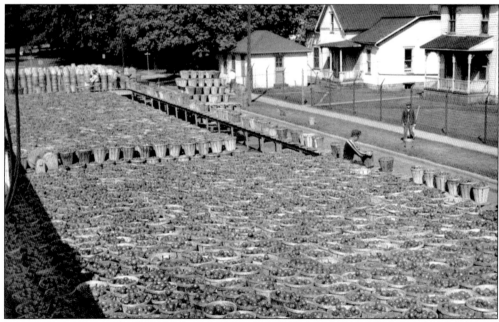

BOUNTIFUL CROP. The H.J. Heinz Bowling Green plant was considered to be the largest tomato catsup factory in the world. It was fitting that it should be planted in one of the richest agricultural centers around. The aroma of catsup cooking could be smelled for miles. Heinz was one of the city's major employers until the factory closed in 1975. (Courtesy WCHS.).

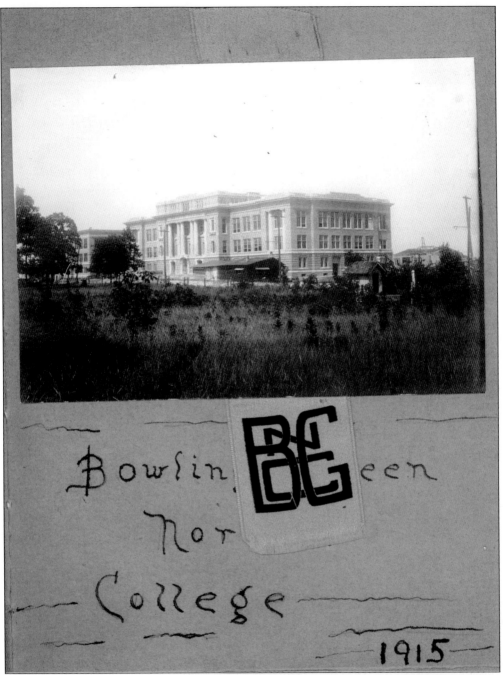

THE BOWLING GREEN STATE NORMAL COLLEGE ADMINISTRATION BUILDING. Late in 1915 the college could boast an impressive headquarters in this building, complete with an auditorium, gymnasium, library, classrooms, and space for home economics, industrial arts, and musical instruction. Until the next round of construction was finished, the six grades of the elementary training school were also in this building. Today it is called University Hall. This scrapbook page was made for a class project by one of the early graduates, Martha Alice Harvey Parquette. (Courtesy CAC-BGSU.)

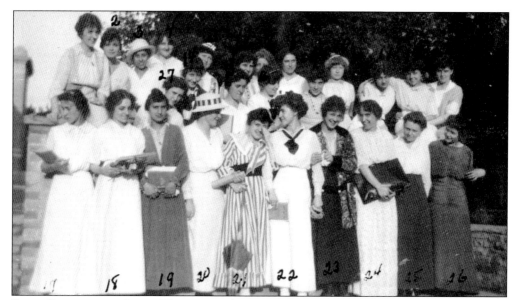

FIRST GRADUATING CLASS. The inaugural commencement ceremony for the Normal College's first graduating class was held on a Thursday, July 29, 1915, downtown at the Chidester Theater (formerly the Hankey Opera House). Thirty-five young women received diplomas for completing the two-year course of study in elementary education at the Toledo Teacher Training School and a summer at the Normal College. A snapshot of the first graduates appears here. (Courtesy CAC-BGSU, M. Parquette.)

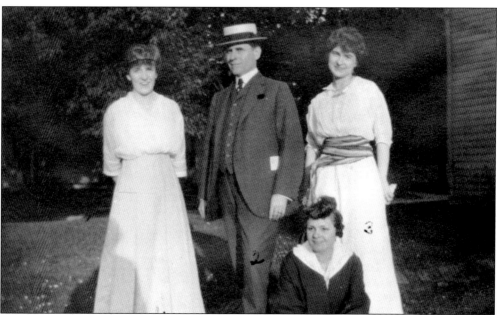

FIRST PRESIDENT, DR. HOMER B. WILLIAMS. Dr. Williams of Sandusky, Ohio, served as the first president of Bowling Green State Normal College from 1912 until 1937. He is seen here with three graduates of the class of 1915. From left to right are Lucille Chambers, Dr. Williams, Elgin Munson, and Irene Rogers. Williams Hall, originally North Dorm, was the first building to open on campus in 1915 and would be named after Homer B. Williams. (Courtesy CAC-BGSU, M. Parquette.)

DR. EDWIN L. MOSELEY. When classes first began at the college in the fall of 1914, Dr. Moseley was one of the first faculty members hired. He was a science professor who remained at the college until his retirement in 1936. He continued as curator of the campus museum until his death in 1948. The science building would be named for him. He is pictured here with a class visiting Bowling Green's P.M. Davidson Ice Plant. (Courtesy K. Schneider.)

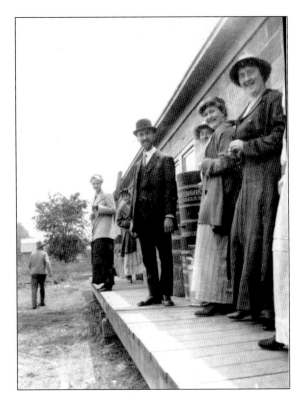

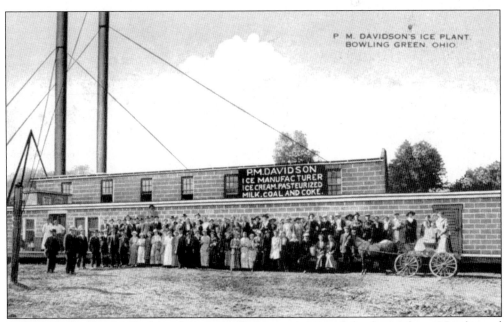

DAVIDSON ICE PLANT. Perhaps this postcard image was captured the day professor Moseley and his class were visiting the Bowling Green ice plant. (Courtesy CAC-BGSU.)

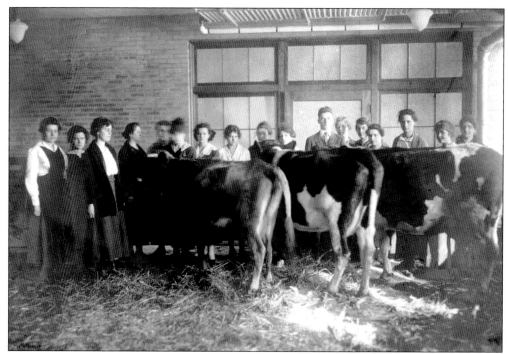

CATTLE CARE. Students at Bowling Green State Normal College could take such classes as "Farm Animals" and "Dairying." One such class with cows is pictured in the basement of the science building (Moseley Hall). (Courtesy CAC-BGSU.)

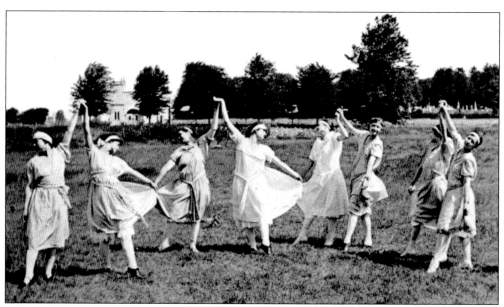

"DANCING ON THE BOWLING GREEN." This 1918 *Bee Gee* yearbook photo captures the spirit and lighter side of college life. In the background can be seen Bowling Green's Oak Grove Cemetery (1873) and mausoleum (1909), at that time on the outskirts of the city. The earlier *c.* 1840 cemetery on Ridge Street was relocated here to a circular sand dune in 1885. Bowling Green State University now surrounds the burial ground. (Courtesy CAC-BGSU.)

RIDGE STREET SCHOOL FIELD. In 1921 the college football team, only three years old, defeated Findlay 151 to 0 on the grounds of the Ridge Street School. By 1927 the college's athletic teams were no longer the Normals but became the Falcons, as they are still known today. In 1937 the first campus football stadium was opened. By the late 1960s the current stadium was built. It would be named for Doyt Perry, notable Bowling Green State University athlete and football coach. (Courtesy CAC-BGSU.)

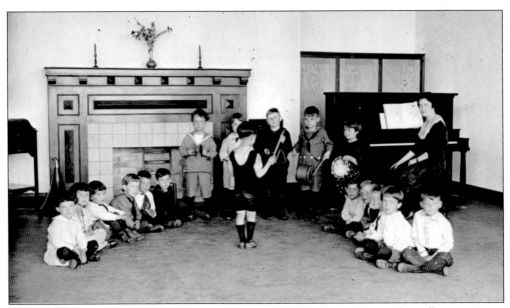

"MUSIC MAESTRO, PLEASE." Pupils and their teacher in music class at the college's training school are pictured in this photo from the 1920s. (Courtesy CAC-BGSU.)

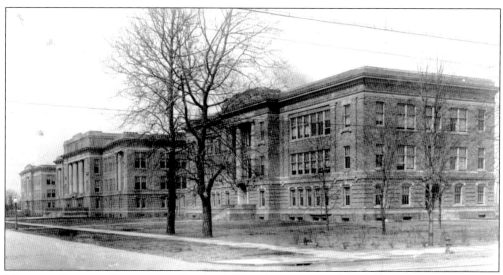

NORMAL COLLEGE BUILDINGS. By the 1920s plans were underway for campus expansion. The college's main buildings appear here from left to right: Science (Mosley), Administration (University Hall), and the Training School (Hanna Hall). The two women's dormitories and a powerhouse are not pictured. A library (McFall Center) and a gymnasium were realized by the late 1920s and an athletic field by the late 1930s. In the college's first 15 years the student body increased from 304 to 950. (Courtesy CAC-BGSU.)

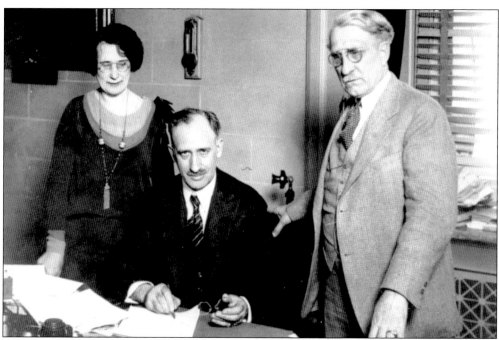

BOWLING GREEN STATE COLLEGE. By 1929 the Normal College had expanded in size and curriculum (colleges for liberal arts as well as education) to such an extent that the Emmons-Hanna Bill was enacted to change the institution's name to Bowling Green State College. Here State Representative Myrna Hanna and Senator V.D. Emmons flank Governor Myers Y. Cooper as he signs the bill. (Courtesy CAC-BGSU.)

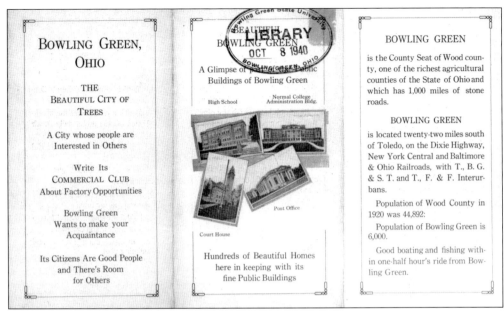

BOWLING GREEN, OHIO

THE
BEAUTIFUL CITY OF
TREES

A City whose people are
Interested in Others

Write Its
COMMERCIAL CLUB
About Factory Opportunities

Bowling Green
Wants to make your
Acquaintance

Its Citizens Are Good People
and There's Room
for Others

BEAUTIFUL
BOWLING GREEN

A Glimpse of painted Public
Buildings of Bowling Green

High School / Normal College Administration Bldg.

Court House

Post Office

Hundreds of Beautiful Homes
here in keeping with its
fine Public Buildings

BOWLING GREEN

is the County Seat of Wood coun-
ty, one of the richest agricultural
counties of the State of Ohio and
which has 1,000 miles of stone
roads.

BOWLING GREEN

is located twenty-two miles south
of Toledo, on the Dixie Highway,
New York Central and Baltimore
& Ohio Railroads, with T., B. G.
& S. T. and T., F. & F. Interur-
bans.

Population of Wood County in
1920 was 44,892:

Population of Bowling Green is
6,000.

Good boating and fishing with-
in one-half hour's ride from Bow-
ling Green.

BOWLING GREEN COMMERCIAL CLUB BROCHURE. The city's many assets were promoted during the 1920s in this small publicity sheet. Early in 1929 the Commercial Club joined the Ohio Chamber of Commerce and became the Bowling Green Chamber of Commerce. (Courtesy CAC-BGSU.)

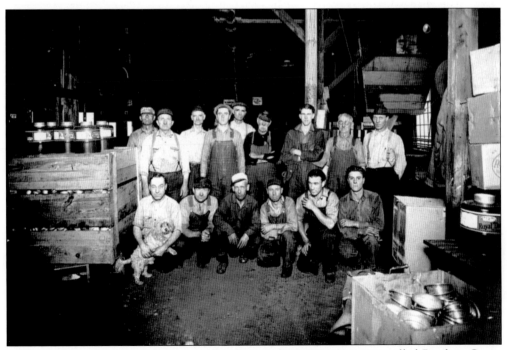

ROYAL MANUFACTURING COMPANY. Small manufacturing companies called Bowling Green home in the early 1930s. Royal Manufacturing was known for its insulated thermal jugs and was located near the New York Central tracks on Lehman Avenue. After a 1953 fire the company moved to a Maple Street location on the west side of the city. (Courtesy CAC-BGSU.)

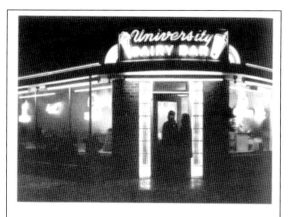

UNIVERSITY DAIRY BAR

Located Across From Sorority Row

A Complete Line of Grade "A" Products
Delivered Fresh Daily To The Home or
Organization

DAIRY DELIGHTS AT THE UNIVERSITY DAIRY. Bowling Green was practically bathing in milk products. There was the Sanitary Dairy, Meadow Brook Dairy (owned by Lippert Creamery Company), A.E. Hughes and Company, the Buckeye Dairy Company, and Miller's Gold Seal Dairy to list a few. The Harms Ice Cream Company was hailed "the Cream of Wood County." The University Dairy at 531 Ridge Street sat at the edge of campus and also operated a popular dairy bar. (Courtesy CAC-BGSU, 1956 *Key*.)

BLOOMING BUSINESS. Families in flowers have been a big part of the city's history. Brigham's Flowers dated from the 1890s. Their greenhouse at 1036 North Main Street is pictured here with three generations of Brighams. From left to right are Janet, Marilyn, and Orma Brigham *c.* 1938. Harold Milnor's Flower Shop dated back to an early florist shop on West Wooster Street opened by Harold's father. Klotz Flower Farm on Napoleon Road is probably the last family florist still in operation here. (Courtesy M. Brigham Glenn.)

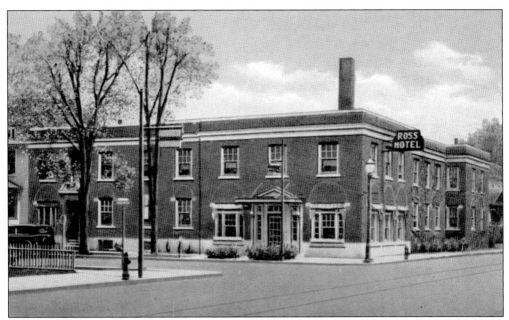

Ross Hotel. On July 4, 1894, Charles C. and Rebecca J. Ross, former owners of the Lease House and operators of the Hotel Brown, bought the Russell House located on the corner of North Prospect and East Wooster Streets. In April 1922 the 1870 wooden frame structure was replaced with a 40-room brick building called the Ross Hotel. It opened November 30 of that year. The famous Von Trapp Family singers were once guests. (Courtesy WCHS.)

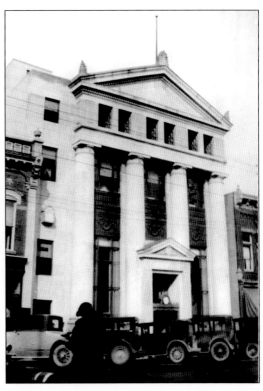

New Bank Building, 1926. By 1905 A.E. Royce's Commercial Bank Company became the Commercial Bank and Savings Company and by 1926 occupied a new building. Five months before the stock market crash of 1929, however, financial irregularities caused the bank to close. By fall of 1931 the Bank of Wood County would open. The new bank and the city eventually weathered the county's agricultural depression of the late 1920s and early 1930s. (Courtesy CAC-BGSU, P. Schmitz.)

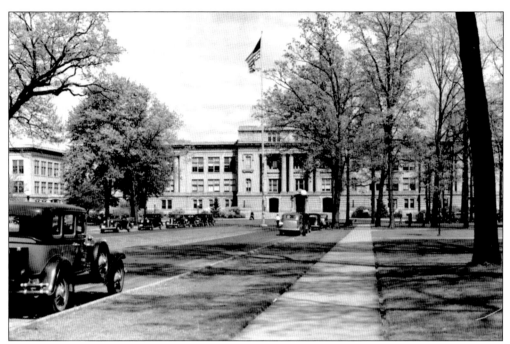

STATE MENTAL INSTITUTION? Bowling Green State College also faced crisis is 1933 when the Ohio General Assembly severely cut appropriations. The Ohio Senate Finance Committee proposed that one of the state colleges be converted into a mental hospital. Bowling Green, being among the smallest of the state colleges, was targeted as the demand for welfare institutions multiplied during the Depression and no money was available to build such facilities. Thankfully northwest Ohio residents rallied and stopped the closing. (Courtesy CAC-BGSU.)

BOWLING GREEN STATE UNIVERSITY. In 1935 a state bill changed the college into a university. The faculty and students posed for this photo to commemorate the institution's final name change. (Courtesy CAC-BGSU.)

82

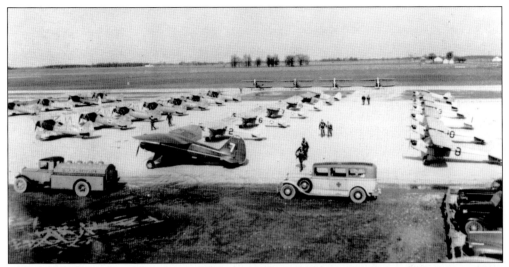

BRICKER FIELD. The Wood County Airport epitomizes cooperation between the city, county, and university. It was dedicated in 1942 and named after Ohio Governor John W. Bricker. The 120-acre airport expanded the size of BGSU and was its economic salvation during WWII when enrollment dropped due to enlistments from 1,600 in 1940–1941 to 842 in the fall of 1943–1944. Bricker field was utilized for Civilian Pilot Training Programs around 1939 followed by Navy V-5 and V-12 programs. (Courtesy CAC-BGSU.)

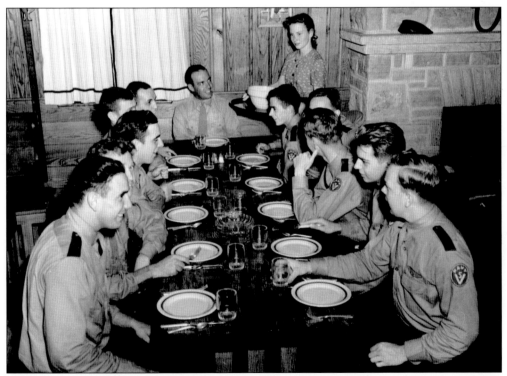

V-5 SERVICEMEN DINING AT THE FALCON'S NEST. Servicemen were a common sight on campus in the war years. Here a group was photographed inside what at that time would have been the "new" Student Union—the university's first. (Courtesy CAC-BGSU.)

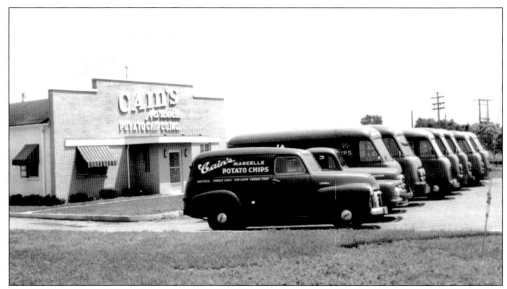

CAIN'S POTATO CHIP COMPANY, INC. While tomatoes were being made into catsup over at Heinz on the north side of Bowling Green, potatoes were being made into chips at the south end of town. The Cain family began the business at their home on Lehman Avenue in 1936 with only one delivery truck. By 1953 they had moved to an expanded facility on Napoleon Road. In 1977 the company and its fleet of almost 50 delivery trucks would be sold. (Courtesy WCPL.)

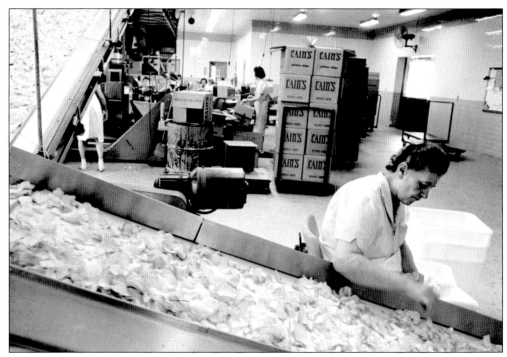

CAIN'S POTATO CHIP EMPLOYEES. The temptation to taste the chips while packaging them seems not to trouble these ladies at the potato chip factory. Activities at the plant were curtailed during WWII due to wartime restrictions. (Courtesy CAC-BGSU.)

DAYBROOK HYDRAULIC CORPORATION PLANT. Herbert O. Day, chief engineer, and A.F. Brooker, sales manager at St. Paul Hydraulic Hoist Company, left their jobs and in 1939 opened their own business in Bowling Green in the former Crystal City Glass Company factory on Lehman Avenue. They made hoists and dump truck bodies. During WWII they introduced a "pontoon bridge" and a laying crane for the Army and Navy. After the war their new lines would be distributed nationwide. (Courtesy CAC-BGSU.)

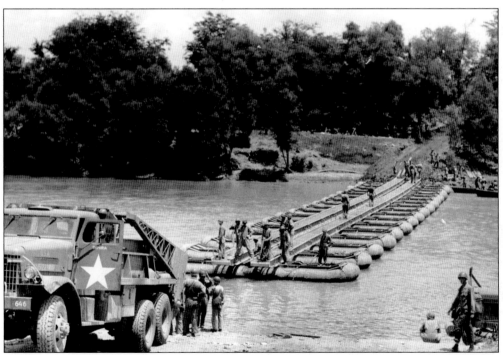

DAYBROOK PONTOON BRIDGE. Former Bowling Green Mayor Alva Bachman was instrumental in helping Daybrook get established. He apparently commented that "General George Patton used one of these pontoon bridges to cross the Rhine River and surprise the Germans." (Courtesy WCHS.)

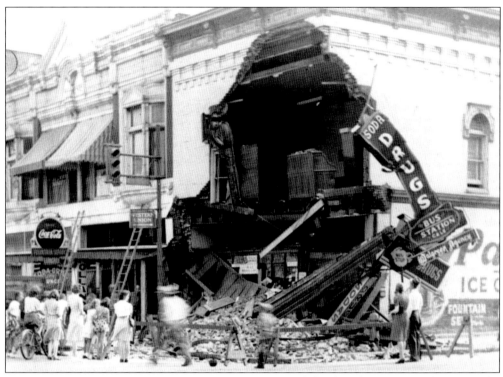

LINCOLN BUILDING WRECKED. August 4, 1944, a truck hauling livestock crashed into the Lincoln Building at the northeast corner of Main and Wooster Streets destroying its late nineteenth century detailing. The building was given a new brick façade facing Main Street. The original Italianate features, however, can still be seen along the East Wooster Street side of the building. (Courtesy WCHS.)

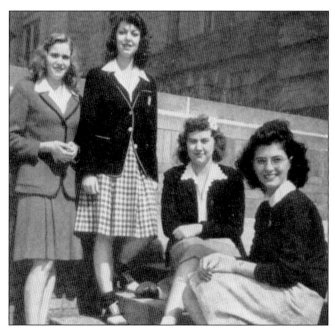

EVA MARIE SAINT, BOWLING GREEN STATE UNIVERSITY CO-ED. In 1944 Eva Marie Saint pictured at far left was president of the sophomore class. She switched her major from education to speech/ drama and graduated in 1946. She then pursued an acting career in New York City and starred in 1953 opposite Lillian Gish in *The Trip to Bountiful*. She won an Oscar in 1955 for *On the Waterfront*. BGSU gave her an honorary degree in 1982 and named a campus theater for her in 1987. (Courtesy CAC-BGSU, 1944 Key.)

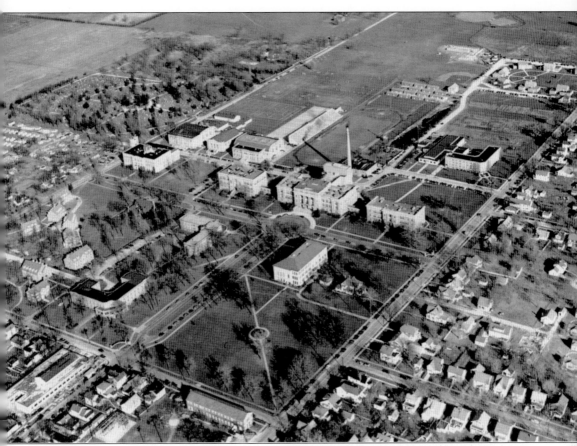

AERIAL VIEW OF BOWLING GREEN STATE UNIVERSITY c. 1950. After WWII the university benefited from the GI Bill and Army ROTC. Enrollment in 1944–1945 was 1,349 and climbed to over 2,000 in the second semester of 1945–1946. By 1946–1947 it was almost at 4,000. The veteran inundation swelled the figures to almost 4,700 in 1949. At that time there were 233 faculty members. Post WWII temporary housing for the servicemen had to be erected to handle the influx. "The huts" are visible in the photo just east of the football stadium. During the 1940s the number of campus buildings jumped from 12 to 57. (Courtesy CAC-BGSU.)

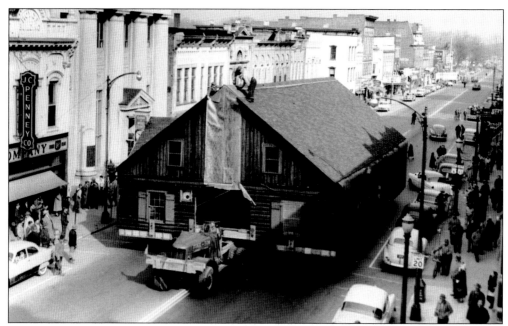

FALCON'S NEST ON THE MOVE. In 1958 the second Student Union opened at the university. Its predecessor, a log cabin-style building, opened in 1942. Fondly remembered as "the nest," it was sold to the American Legion Post in Portage to serve as their meeting hall. Here it is seen being moved along Main Street toward Portage only a few miles south of Bowling Green. (Courtesy CAC-BGSU.)

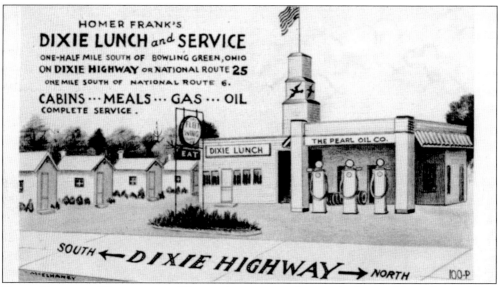

DIXIE HIGHWAY HOSPITALITY. The city's major north– south thoroughfare, Route 25 or Dixie Highway or Main Street, brought a steady stream of travelers through the city known as a "marriage mill" from the 1920s until about WWII. Couples could jump onto the Dixie come to Bowling Green, and quickly marry any time of day. Along the highway various accommodations sprouted, such as Green Gables Tourist Park, Angel's Blue and White Tourist Court, and Homer Frank's Dixie Lunch and Service. (Courtesy Brown PCL–BGSU.)

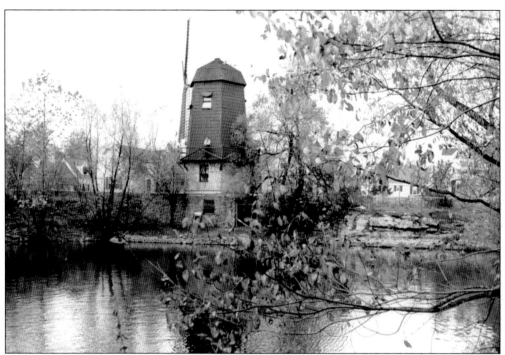

URSCHEL POND. The old stone quarry on Clough Street became Kelly Swimming pool in the 1920s thanks to the Women's Club. In the mid 1930s, the "pool" and land were sold to Bertis H. Urschel founder of Urshel Engineering Company, or machine works, which produced various parts for government contracts during and after WWII. Mr. Urshel is remembered for the distinctive apartment building he had constructed in the shape of a windmill overlooking the quarry pond. (Courtesy CAC-BGSU.)

POND RULES. In 1949 Mr. Urshel sold to Bowling Green State University part of his property, including his residence, nearby apartments, and most of the quarry. By the 1950s this old quarry swimming spot was providing summer refreshment for university staff and students. (Courtesy CAC-BGSU.)

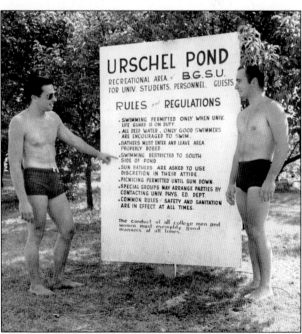

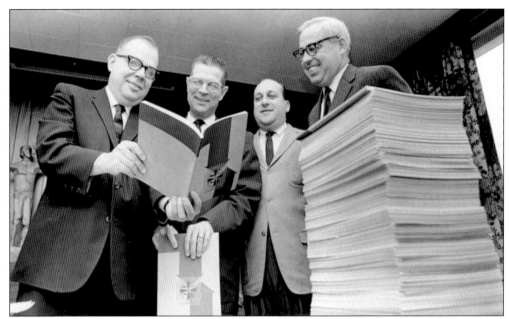

1965 CITY BUSINESS. Bowling Green councilman and later mayor Charles E. Bartlett is seen here on the left reviewing a city industrial brochure with James Huntington, Robert K. Schneider, and Bowling Green State University President William T. Jerome III. (Courtesy WCPL.)

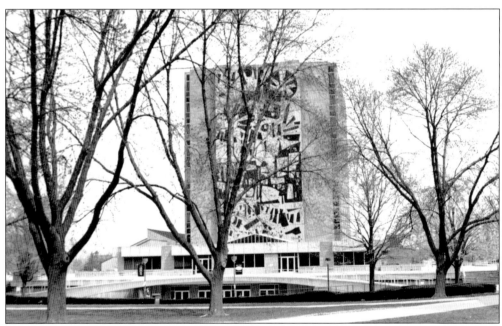

JEROME LIBRARY AT BOWLING GREEN STATE UNIVERSITY. By 1960 the university's enrollment rose to over 6,000 students and during the decade would more than double. Faculty numbers increased from 254 to almost 700. The number of permanent buildings rose to 80 and the campus property to about 1,200 acres. Jerome Library was constructed late in the 1960s as part of campus development. Its Popular Culture, Music, Great Lakes, and Archival Collections draw scholars from around the world. (Courtesy the author.)

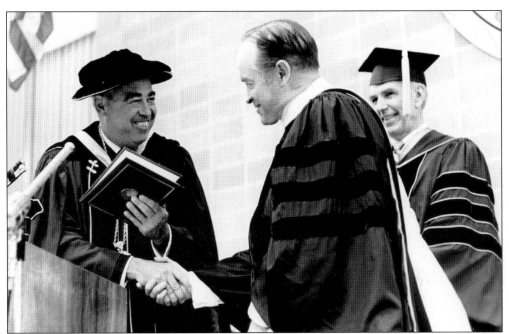

THANKS! Comedian Bob Hope was bestowed a Doctor of Humanities degree by President William T. Jerome III during commencement in June 1969. Prior to this, comedian Joe E. Brown, former Holgate, Ohio, native, received an honorary degree in 1949. The Joe E. Brown Theater in University Hall bears his name. Funny man Tim Conway was a BGSU grad. (Courtesy CAC-BGSU.)

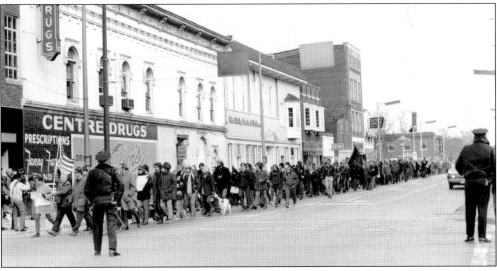

ON THE MARCH. Wednesday, May 6, 1970, just days after the Kent State shootings, about 8,000 students and Bowling Green citizens led a procession on East Wooster Street. This was a peaceful alternative to many violent reactions at other universities across the country. Bowling Green State University was permitted to stay open due to calm leadership and cooperation of faculty, students, and community leaders. (Courtesy CAC-BGSU.)

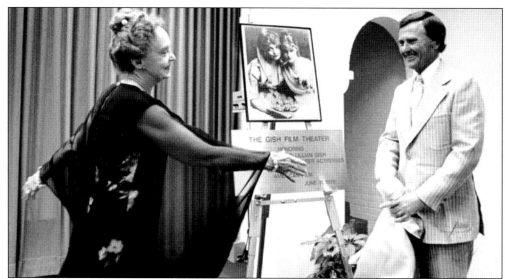

LILLIAN GISH AND DR. HOLLIS A. MOORE JR. DEDICATE GISH FILM THEATER. Between 1970 and 1981, Dr. Moore, the university's seventh president, oversaw an expansion in the curriculum and a state mandated ceiling of 15,000 full-time equivalent students. He is pictured here with legendary movie actress and Ohio native Lillian Gish at the June 11, 1976, dedication of 105 Hanna Hall as a movie theater honoring Lillian and her movie star sister Dorothy. Lillian received an honorary doctorate from the university that same year. (Courtesy CAC-BGSU.)

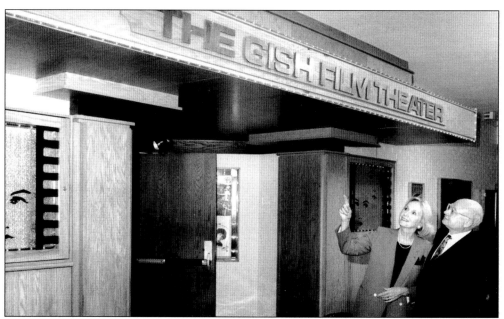

REDEDICATION AT THE DOROTHY AND LILLIAN GISH FILM THEATER. Alumna Eva Marie Saint and professor Dr. Ralph H. Wolfe, founder of the Gish Film Theater are pictured admiring the marquee at the 1990 rededication of the only theater in the world named for the famous acting sisters. The theater's international film series and Sunday matinees each semester are a popular addition to the city's cultural offerings. (Courtesy CAC-BGSU.)

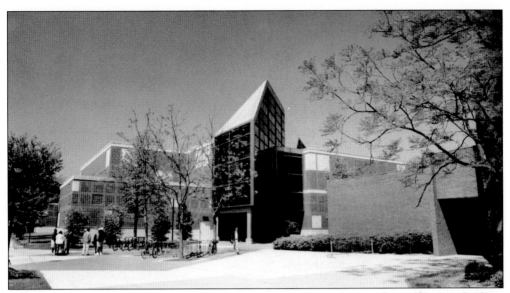

OLSCAMP HALL. Technologically equipped local and distance learning center might be a fitting description for the 1994 state of the art classroom building named for eighth Bowling Green State University president, Paul J. Olscamp. This facility embodies the university's mission in the new century to stay cutting edge in the technological enhancement and advancement of education. (Courtesy CAC-BGSU.)

BOWEN-THOMPSON STUDENT UNION. This is not your grandmother's "Falcon's nest." Heralding a new century was a new multi-million dollar Student Union at BGSU. Town and gown mix at the lavish new union opened in 2002 with its grand ballroom and spacious facilities for community and university gatherings. Restaurants, a theater, and a two-story bookstore are just a few of its amenities. (Courtesy the author.)

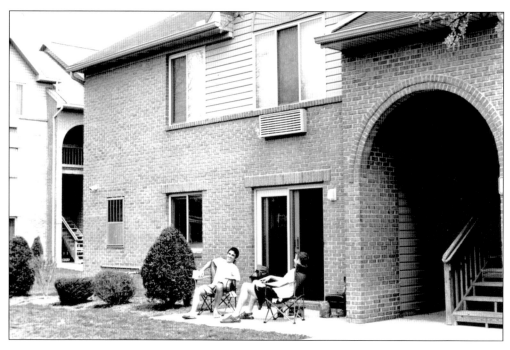

LIVING IN A UNIVERSITY TOWN. Bowling Green State University is the city's largest employer with over 3,000 employees and nearly 20,400 students. Cooper Industrial Products employs over 1,100. Local real estate interests are busy keeping up with the demand for housing in the city. After the Heinz plant burnt, the land remained undeveloped until about the 1990s when its owners began constructing a "student village" called the Heinz-Site Apartments. Once again enterprise triumphed in Bowling Green appropriately on Enterprise Street. (Courtesy the author.)

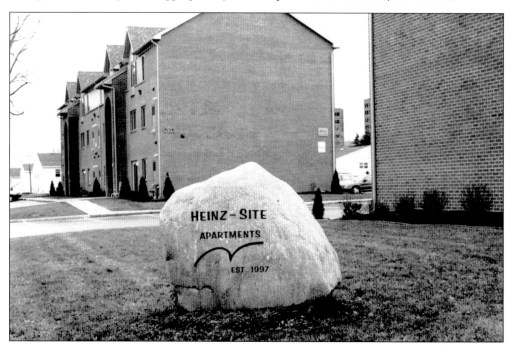

Five

MENTOR OF
CITIZENS

SOUTH MAIN STREET SCHOOL CLASS. Bowling Green's first residence dates from 1833 and the first school from 1834 in the borrowed Thurstin cabin near present day down town. In 1835 the first "real" school was built on the northeast corner of Napoleon road and Main Street. North of this location the brick South Main Street School was erected in 1889. The building is still used for elementary grades such as Bin McLish's class photographed here *c.* 1950. (Courtesy CAC-BGSU.)

CHURCH STREET SCHOOL. This 1901 school building embodies Bowling Green's willingness to use its resources as much as possible to benefit the community. After first serving as a school and later as spill over classroom space, it would become the public library and after that the City Administrative Services Building. In the mid 1850s Bowling Green's first frame school house was apparently located south of this location at the site of the 1890s city building. (Courtesy WCPL.)

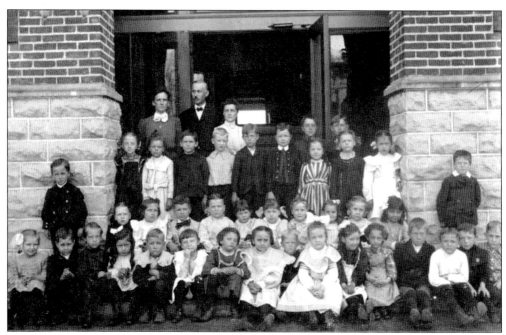

CHURCH STREET SCHOOL CLASS. This early twentieth century school picture features a young Minniebelle Conley in the front row eighth from the left. (Courtesy WCHS.)

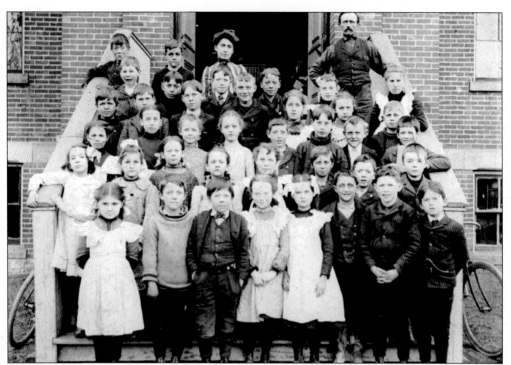

RIDGE STREET SCHOOL CLASS. The *c.* 1910 photo of students in Miss Biggs' fourth grade class was taken in front of the 1888 school building on Ridge Street. An 1836 log school had stood nearby. (Courtesy WCHS.)

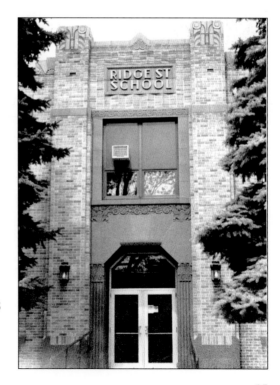

"NEW" RIDGE STREET SCHOOL. The 1888 building was replaced in 1931 with a new art deco-style school building, which is currently still in use in the city's first ward. (Courtesy the author.)

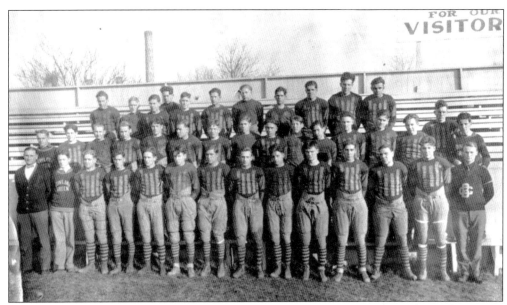

BOWLING GREEN HIGH SCHOOL BOBCATS FOOTBALL TEAM. Part of the Ridge Street School yard was used as a playing field for the local high school and college football games until approximately the mid 1930s. Pictured here is the high school football team in the mid 1920s. (Courtesy CAC-BGSU.)

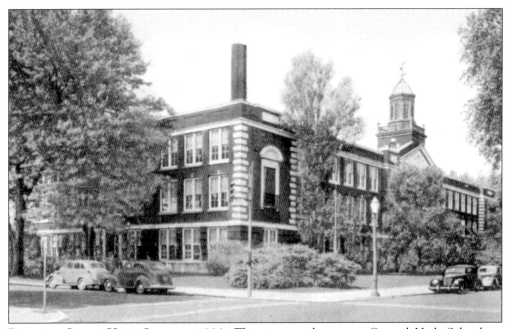

BOWLING GREEN HIGH SCHOOL, 1928. The nineteenth-century Central High School on South Grove Street was replaced in 1915 with a new building. By 1928 a larger senior high school was constructed on the corner of West Wooster and South Church Streets. The 1915 building became the junior high. (Courtesy CAC-BGSU.)

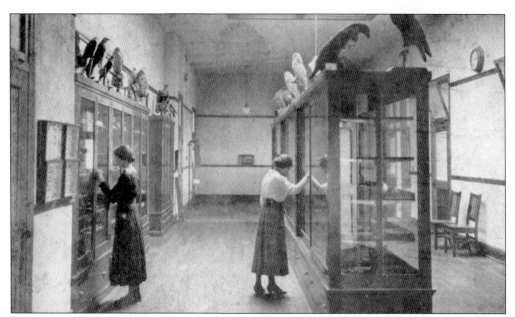

COLLEGE MUSEUM HOME TO INDIAN MISSION SCHOOL BELL. The story was told that the Indian Mission School (1822–1834) on the Maumee River had a bell that was purported to have been brought to Bowling Green and installed about 1835 in the Bell School House south of Pearl Street and west of Martindale Road. Later the Plain Township trustees had the bell removed and transferred to the college's museum with its various historic artifacts overseen by Dr. Moseley. (Courtesy CAC-BGSU.)

PROUT CHAPEL. In 1951 the Mission School bell was installed in the new chapel on the Bowling Green State University campus. The New England-style chapel, named for university president Frank Prout, is used for interdenominational worship services and is a popular wedding spot. (Courtesy the author.)

PLAIN CONGREGATIONAL CHURCH. This 1835 church is considered to be the earliest congregation in the Bowling Green vicinity to still be meeting at the original location at the southwest corner of Poe Road and Liberty High Road. Early Bowling Green settler Elisha Martindale was excommunicated from this body in 1839 (later reinstated), four years after becoming a charter member. At one time the church had the largest membership of any church in the Maumee Valley. (Courtesy WCPL.)

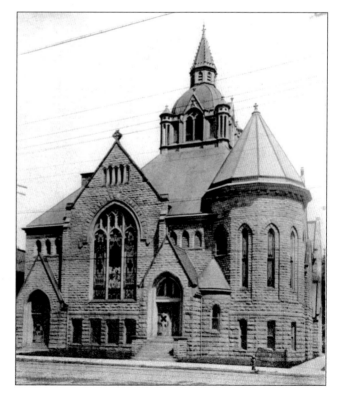

METHODIST CHURCH. The first church in Bowling Green was said to be Methodist. Early classes and meetings were conducted at the Bell School starting about 1835. By 1846 the Methodists erected their first church building in town on the northwest corner of South Main and Washington Streets. In 1872 a brick church was completed at the northwest corner of East Wooster and North Prospect Streets and would be replaced in 1897 with a stone edifice. (Courtesy *1908 BG*, Walker.)

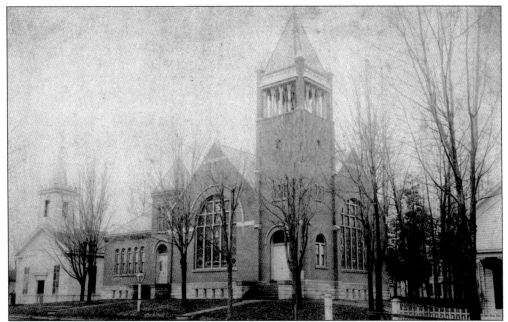

PRESBYTERIAN CHURCH. The second church established in Bowling Green was apparently the First Presbyterian Church in 1855. There have been three churches at the 126 South Church Street site. The most recent was finished in 1922. This photo captures the early frame church to the left of the second building. In 1862 another early church, the Seventh-Day Adventists, established the first congregation of its kind in Ohio just north of town. (Courtesy WCHS.)

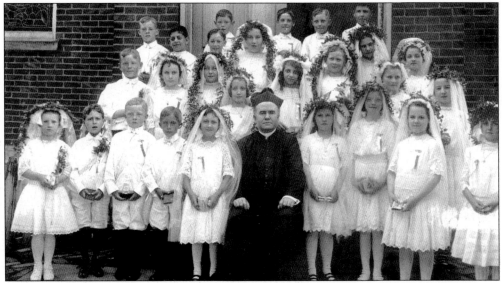

SAINT ALOYSIUS. Aloysius Pfeiffer, a local farmer and church councilman, won the drawing to name the first Catholic church in Bowling Green. It was constructed on South Enterprise Street in the late 1800s. The current Romanesque-style house of worship, dedicated in 1929, stands at the northeast corner of South Summit and Clough Streets. Reverend James A. Lane is seen here in a first communion photo taken with 24 children in June 1911. (Courtesy CAC-BGSU, BG Chamber of Commerce.)

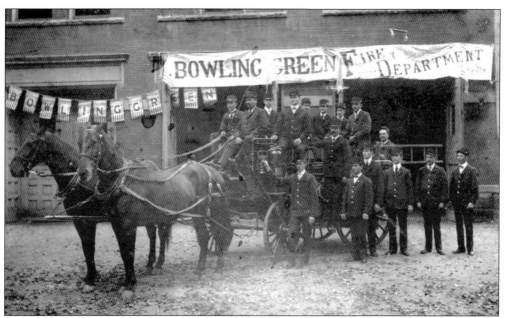

BOWLING GREEN FIREMEN. After the downtown was devastated by fire in 1887 and 1888, the demand for an organized fire department was apparent. By the early 1920s advances in fire fighting equipment motorized the department. "The old fire horse team of 'Dick' and 'Ned' was retired to the Wood County Home farm." The fire fighters are photographed at the city building *c.* 1901. (Courtesy WCHS.)

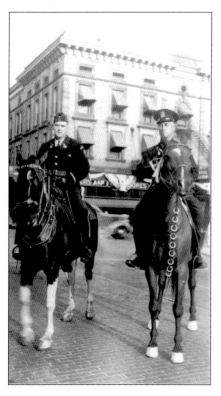

POLICE ON HORSEBACK. Posed across from the Millikin Hotel in the 1930s are Guy Spitler, future Bowling Green police chief, and Harold Fletcher. (Courtesy CAC-BGSU, M. Fletcher Decker.)

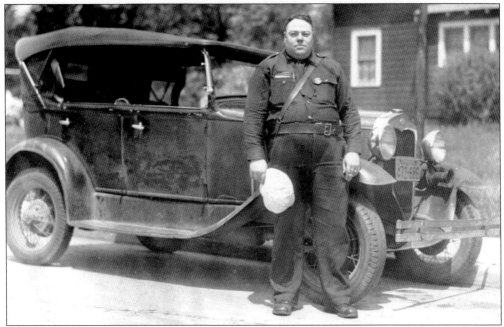

DUTY CALLS. The Bowling Green Police Department was officially established in 1903, and Joseph D. Reed appointed the city's first police chief. In 1928 Carl "Shorty" Galliher became chief—a man the newspaper hailed as being afraid of nothing. It was a good thing since on April 16, 1931, the chief was engaged in a shootout on South Prospect Street, north of Clough Street. William "Billy the Baby-Faced Killer" Miller was killed, and the notorious Frank Mitchell, also know as "Pretty Boy Floyd," escaped. (Courtesy *Sentinel-Tribune*.)

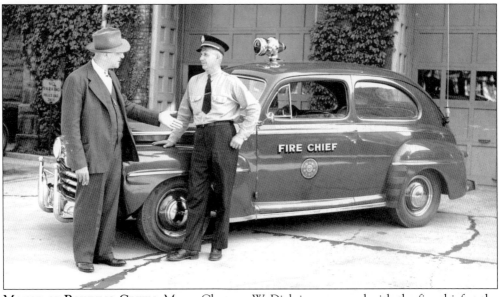

MAYOR OF BOWLING GREEN. Mayor Clarence W. Dick is seen posed with the fire chief at the Bowling Green City Building in 1948. The town's first official mayor was John C. Wooster, elected February 1856 after Bowling Green was incorporated the previous year. Over 40 men have served as mayor since then. (Courtesy CAC-BGSU.)

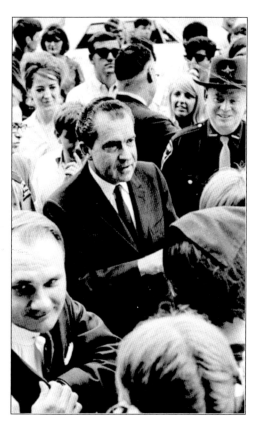

CONGRESSMAN DELBERT L. LATTA.
Bowling Green citizen and Ohio Fifth U.S.
Congressional District Representative Latta
served area constituents in Washington D.C.
from 1959 until 1989. His papers are housed
at BGSU's Center for Archival Collections.
Latta is seen here on the left with Wood
County Sheriff "Red" Rife flanking soon-to-be
President Richard M. Nixon in about 1967.
Other Presidents or future Presidents who
came to town included Theodore Roosevelt,
Taft, Harding, Kennedy, Ford, Reagan, Bush,
and Clinton. (Courtesy CAC-BGSU.)

BUCKEYE BOYS STATE. The American Legion sponsors a mock government week every June,
drawing high school youths from all over Ohio to Bowling Green State University. There they
learn about the government directly from lawmakers and elected officials. Local political mentors
include former Congressman Latta, his son Ohio Representative Bob Latta, State Auditor Betty
Montgomery, and Ohio Senator Randall Gardner, among others. (Courtesy *Sentinel-Tribune*.)

WORLD WAR I VETERANS. In 1904 Company H., Second Ohio transferred to Bowling Green. From 1904 until WWI, E.C. Stacy, Charles S. Hatfield, Leon L. Myers, Elmer J. Bowers, and Ray D. Avery served at various intervals as captain. The city was given the National Guard Armory (1910) due to the "efficiency in service of Co. H." In 1909 the company "held the highest shooting or marksmanship record in the United States." Co. H. is posed across Wooster Street in this WWI-era photo. (Courtesy WCHS.)

THE UNITED STATES POST OFFICE. Bowling Green's grand post office was another gem in the city's crown in 1914, thanks to the Commercial Club. Once the city outgrew the building, it was converted into the Bowling Green Senior Citizens' Center, and a larger facility was constructed just south of the business district. Recently the post office was named the Delbert L. Latta Post Office Building. Latta was instrumental in getting funding to build the structure. (Courtesy the author.)

SHAKESPEARE ROUND TABLE. This ladies' literary club first met in 1905 at the home of Mrs. B.F. James. Bowling Green received a public library by August 1928 when the Round Table gifted over 8,000 books to the community. The volumes resided at the high school and later at the Church Street School. Pictured from left to right are Mrs. D.A. Hayor, Miss Abeline E. Halleck, Mrs. J.C. Lincoln, Mrs. J.E. Shatzel, and Mrs. Margaret Kohl. (Courtesy WCPL.)

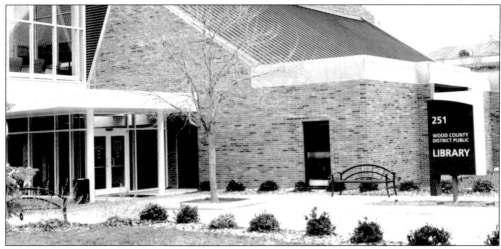

WOOD COUNTY DISTRICT PUBLIC LIBRARY. In 1875 the town had a subscription library operated by the Bowling Green Library Association. Around 1914 a library was housed at the Exchange Bank building. Later it was moved to the McKenzie-Kabig Block on North Main and Court Streets across from the present library. The recently renovated and expanded 1974 library serves almost as a community center for the city with a full calendar of programs and events. (Courtesy the author.)

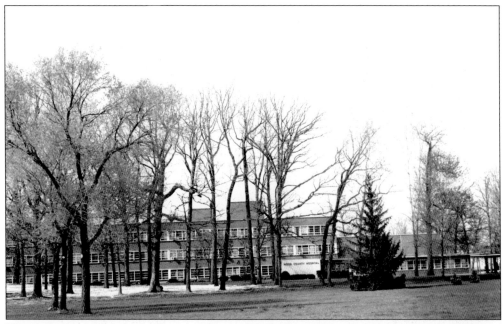

WOOD COUNTY HOSPITAL. The city's hospital opened in 1951 with 54 beds. Between 1954 and now, numerous changes and additions have expanded the facility into an indispensable health care community for the entire county. The active Hospital Guild has contributed enormously to the medical center's success. (Courtesy WCPL.)

FRED UHLMAN AT HIS DOWNTOWN STORE. Prosperous Bowling Green businessman, Fred W. Uhlman, owner of a chain of retail stores, was credited with giving the city its first modern hospital. He gave generous financial support during fundraising efforts for the facility in the mid 1940s. The hospital would be home to Mr. Uhlman in his last years. (Courtesy CAC-BGSU, BG Chamber of Commerce.)

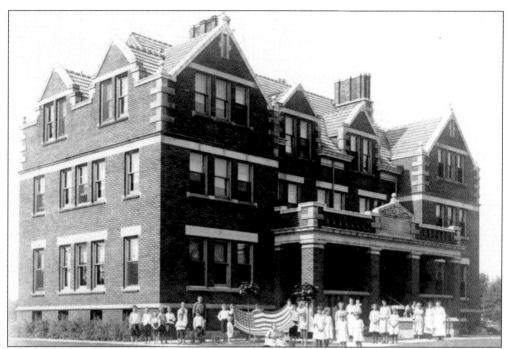

WOOD COUNTY JUVENILE DETENTION HOME. Architect S.P. Stewart and Son designed the stately red brick Children's Home that opened in 1916 at 541 West Wooster Street. A later annex would be designed by J.K. Raney of the Stewart firm. The building could accommodate about 120 needy youths. It was capably run by matron-superintendent Miss Nellie Repass until her death in 1940. With the increased use of boarding homes the facility became obsolete for the care of dependent children. (Courtesy WCHS.)

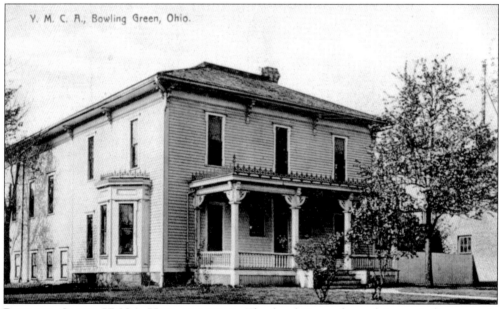

BOWLING GREEN YMCA HEADQUARTERS. The local Y was housed in an Italianate-style building on East Wooster Street. (Courtesy the author.)

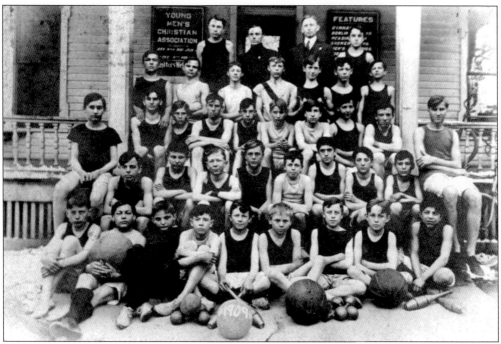

BOYS AT THE YMCA. The Bowling Green Y front porch was the backdrop for this photo of local boys in about 1909. (Courtesy WCHS.)

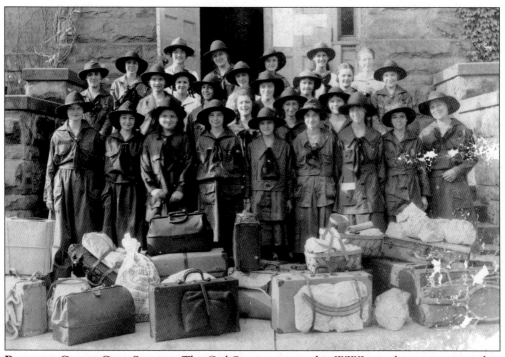

BOWLING GREEN GIRL SCOUTS. The Girl Scouts seen in this WWI-era photo are prepared to go on a trip. The first Bowling Green troop was formed in 1917–1918 and a second troop a year later. (Courtesy CAC-BGSU, BG Chamber of Commerce.)

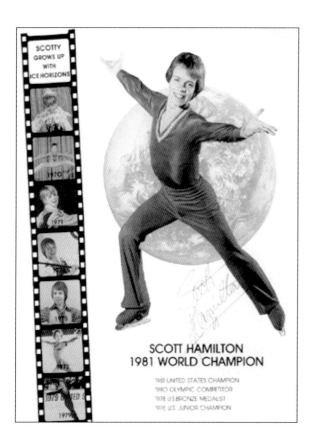

SCOTT HAMILTON
1981 WORLD CHAMPION

1981 UNITED STATES CHAMPION
1980 OLYMPIC COMPETITOR
1978 U.S. BRONZE MEDALIST
1976 U.S. JUNIOR CHAMPION

CHAMPION CITIZEN. Bowling Green native and 1984 Olympic gold medal winner in figure skating Scott Hamilton overcame life threatening health problems by skating in lots of cool air. He frequently returns to his home town to encourage young athletes and to host Ice Horizons figure skating programs at the Bowling Green State University Ice Arena, which opened in 1967. (Courtesy WCHS and WCPL.)

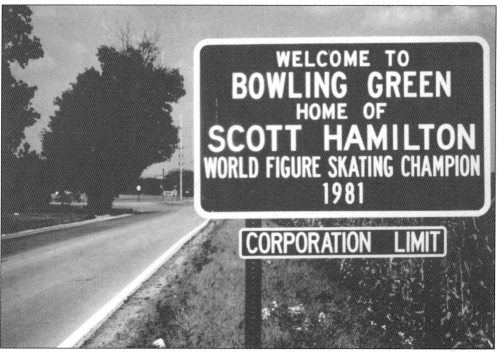

WELCOME TO
BOWLING GREEN
HOME OF
SCOTT HAMILTON
WORLD FIGURE SKATING CHAMPION
1981

CORPORATION LIMIT

Six

BLACK SWAMP FUN SPOT

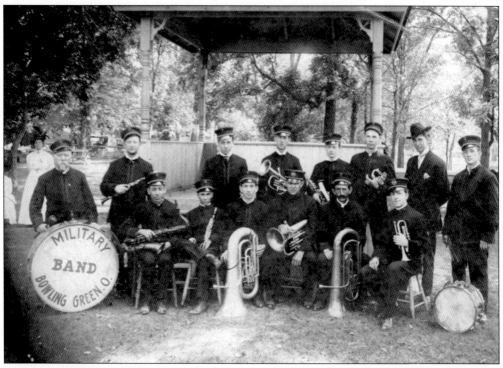

THE LOCAL BAND—A HOME TOWN STAPLE. Bowling Green had more than one band in its history. Pictured in 1911 at the local park was the Bowling Green Military Band. Ralph Crane (seated at far right) was the director, "a fine looking, dignified director," according to *Sentinel-Tribune* Society Editor Miss Minniebelle Conley. Years before this in the 1880s, the Bowling Green Silver Cornet Band was the rage with General D.W.H. Day as drum major and George Parks as leader. (Courtesy WCHS.)

BIGELOW FAMILY BAND. Wednesday night band concerts in Bowling Green featured such entertaining performers as the Bigelow Family, a name linked to the lumber business. The family is pictured c. 1914 with father John H. Bigelow on the bass drum and his wife Etta seated on the far right holding the alto horn. John Bigelow paid for quality musical instruments but was unimpressed with formal musical training so the children taught one another. (Courtesy CAC-BGSU.)

THE MUSICAL MISSES. Jack "Harvey" Bigelow holding the trumpet in the back row of the previous photo, later established an all-girl band called the Musical Misses that played the Keith Circuit in vaudeville theaters around the country. He would return to Bowling Green and open the Bigelow Music Store. He is pictured here performing with his talented ladies c. 1925. (Courtesy CAC-BGSU, MMS 1522.)

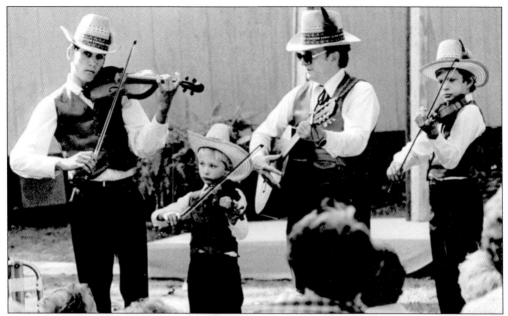

THE DEPUE FAMILY MUSICIANS. Bowling Green State University professor emeritus Wallace DePue is a renowned musician and composer whose sons carry on the family gift. Their vocal talents and violin skills have made them nationally and internationally known. Here as youngsters they are seen performing at the Bowling Green Community Day celebration at the City Park October 2, 1983. Pictured from the left are Wallace Jr., Jason, Wallace Sr., and Alexander Paul. (Courtesy CAC-BGSU, BG Chamber of Commerce.)

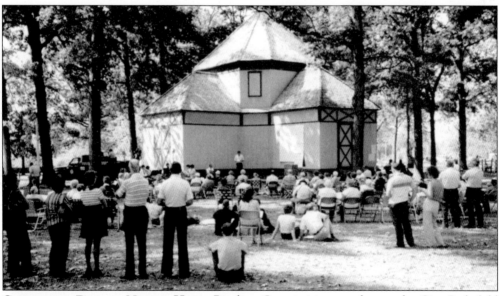

COMMUNITY DAY AT NEEDLE HALL. Bowling Green citizens gather at the City Park (old fairgrounds) during pleasant weather for various community events, musical performances, plays, and the like, many of which seem to include Needle Hall, a remnant of the fairground days. Here Bowling Green gathers on October 2, 1983, for the city's Sesquicentennial Community Day activities. (Courtesy CAC-BGSU, BG Chamber, K. Sergent.)

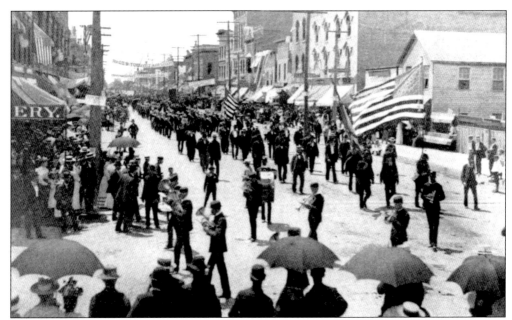

A FAIR DAY PARADE. Bowling Green's Main Street has seen a lot of fanfare. Here a parade at the dawn of the twentieth century moves down North Main Street under Wood County Fair banners and flags and turns onto Court Street. The sign for Avery's livery stable is visible on the left near Hotel Brown. (Courtesy *Picturesque Northwestern Ohio.*)

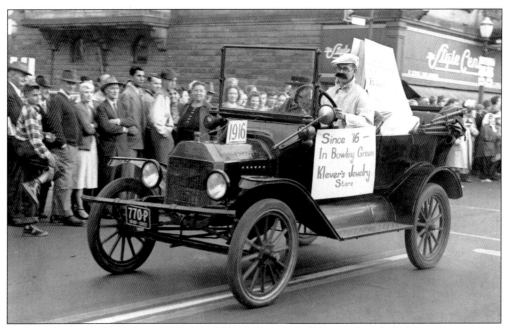

A FALL FESTIVAL PARADE, 1949. The Wood County Fall Festival included this vintage auto entered in the parade for Klevers Jewelry Store, one of the city's old businesses. The Millikin Hotel is seen in the background. Belleville Brothers Meat Market and Deck-Hanneman Funeral home are just a few of the old family run businesses still thriving in Bowling Green. (Courtesy CAC-BGSU, BG Chamber of Commerce.)

A TOMATO FESTIVAL PARADE. The city's rich agricultural bounty included the celebrated tomatoes that the H.J. Heinz Company put into their catsup. In 1938 the Tomato Festival parade would feature such floats as this one with the giant soda sponsored by Rogers' Drugs. (Courtesy WCPL.)

A HOLIDAY PARADE. In November Bowling Green welcomes Santa Claus on Main Street with numerous bands and flocks of floats. With this and the lighting of the community Christmas tree on the library lawn, the holiday season is officially opened downtown. The Food Town balloon was a familiar sight at a number of previous holiday parades. (Courtesy CAC-BGSU, BG Chamber of Commerce.)

115

OLD LYRIC MOVIE THEATER. It has been said that among the oldest movie theaters in Bowling Green was the Lyric at 122/124 North Main Street. It was the smallest of the city's theaters with only 154 seats. It included a small stage for vaudeville performances. Local theater manager Clark Young took over operation of the Lyric in 1916. (Courtesy CAC-BGSU.)

PEOPLES' PICTURE HOUSE. Movie madness swept Bowling Green in a big way. Peoples' with its 300 seats was opened by Ernest Hodgson in a room south of Butler's Drug Store at 158 North Main Street about 1911. The Royal Five Cent Theater was opened in 1909 at 122 North Main. (Courtesy *Sentinel-Tribune*.)

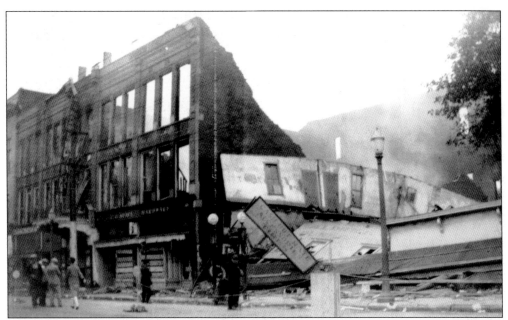

FIRE AT THE DEL-MAR. Murray Chidester prospered in the city's oil boom and bought the former Hankey-Taber Opera House. He renamed it the Chidester. On October 4, 1910, candidate for Ohio Governor Warren G. Harding campaigned there. BGSU's first graduation was held there. In 1918 the theater was sold and renamed the Del-Mar. Clark Young took over its operation in 1920. The theater closed and was destroyed by fire in 1926 just months after the city's newest movie house, the Cla-Zel, opened. (Courtesy CAC-BGSU, P. Schmitz.)

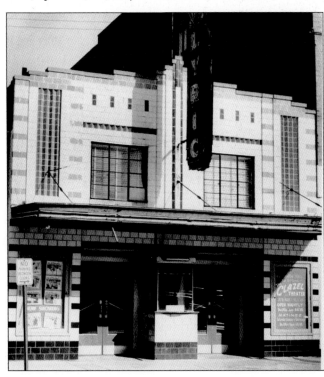

NEW LYRIC MOVIE THEATER. In 1935 Clark Young built the new 300-seat Lyric at 143 East Wooster. He also operated Everybody's Movie Theater in 1920 at 116 North Main Street. (Courtesy *Sentinel-Tribune*.)

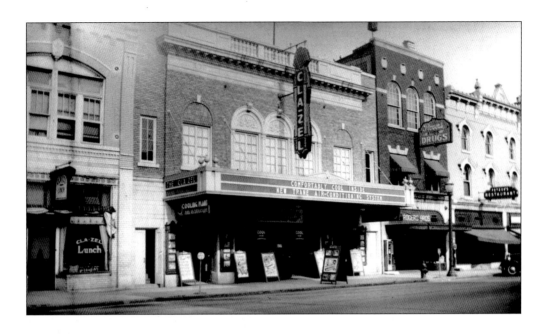

THE CLA-ZEL. The only movie theater still in continuous operation since opening in downtown Bowling Green, and quite possibly the oldest single screen movie house in Ohio still operating, was named for its owners Clark and Hazel Young. It opened at 129 North Main Street to a capacity house on April 21, 1926. S.P. Stewart and Son built the fire-proof $150,000 building, which included a Marr and Colton organ. Currently the Cla-Zel is being revitalized as a city performing arts center. (Courtesy CAC-BGSU, P. Schmitz and S.P. Stewart.)

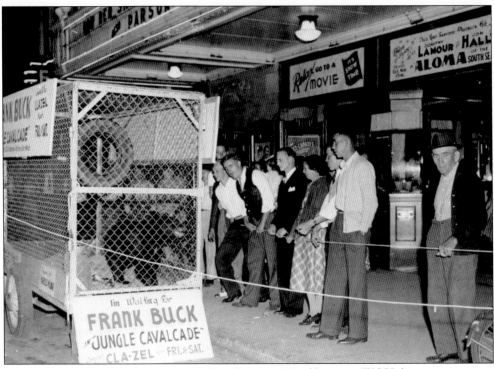

STUDENTS GATHERING OUTSIDE THE CLA-ZEL c. 1950. (Courtesy WCPL.)

BLACK SWAMP PLAYERS. Live community theater performances have been creatively staged in various locations in Bowling Green by the award winning Black Swamp Players established in 1968. The City Park, Woodland Mall, and Bowling Green churches have all hosted performances by the players. (Courtesy CAC-BGSU, Black Swamp Players.)

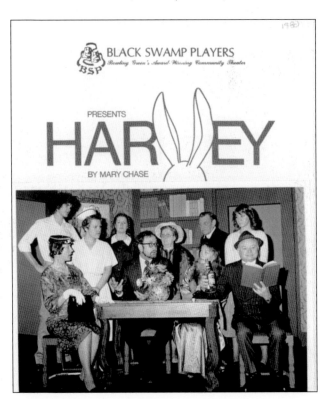

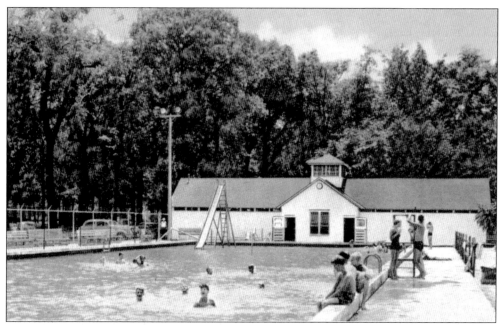

CITY PARK POOL. The City Park was permanently settled on the west side of Bowling Green at the former fairgrounds by the 1930s. It boasts a WPA built stone wall, shelter house, swimming pool, and bath house. The nearby golf course creates a scenic expanse of green between the park and the Bowling Green Country Club to the north along Fairview Avenue. Wintergarden and Carter Parks are just two other notable Bowling Green recreational spots. (Courtesy the author.)

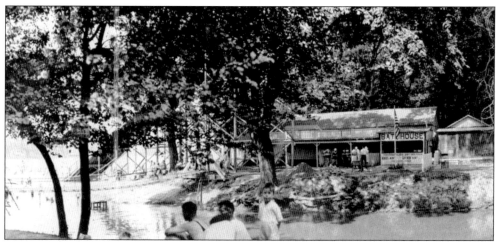

VOLLMAR'S PARK. Just north of Bowling Green along the Maumee River near Haskins, Ohio, was the popular amusement park called Vollmar's. It boasted a dance pavilion, hotel, cabins, picnic grounds, swimming, boating, and rides. Many Bowling Green residents wiled away the summer there. This scenic locale had been used for outdoor recreation from about 1865 until just a few years ago when the park closed. Pictured here in the early 1930s is the swinging bridge and water slide. (Courtesy CAC-BGSU.)

THE ORIENTAL SALOON AND BILLIARD PARLOR. The pool hall was a haven for many a husband and a woe for many a wife. This recreational spot was designed by S.P. Stewart in the Biggs Block on the east side of North Main Street. In this *c.* 1890 photo a survivor of the 1887 fire, the First Baptist Church, appears at the left at 115 East Oak Street. (Courtesy CAC-BGSU.)

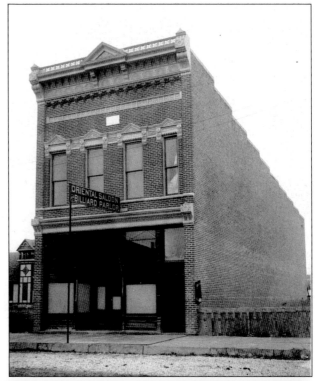

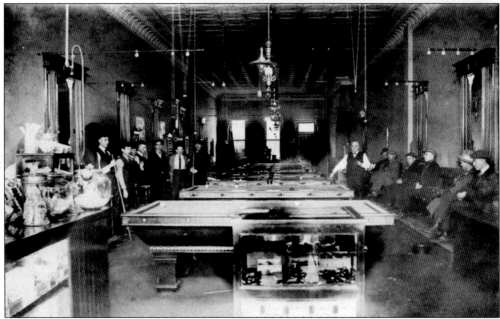

BILLIARD PARLOR INTERIOR. It was said that Bowling Green sported at least four billiard rooms in 1916, including Branigan Brothers Billiards at 104 South Main, Coleman and Company at 146 North Main, Grames and Murdock at 110 North Main, and Shrader and Wilson at 162 N. Main. This photo was possibly taken inside one of these Bowling Green billiard parlors. (Courtesy CAC-BGSU, BG Chamber of Commerce.)

HISTORICAL CENTER WOOD COUNTY DAY. Among the historical society's many popular events held annually on the grounds of the former Wood County Infirmary is Wood County Day. Here history lives through military reenactments, demonstrations of forgotten handcrafts, contests, tours, and such. (Courtesy WCHS.)

NATIONAL CONSTRUCTION EQUIPMENT MUSEUM. This unique collection of antique construction machines is located at 16623 Liberty High Road near Bowling Green. The organization periodically hosts the national convention of the Historical Construction Equipment Association attracting between 6,000–8,000 visitors. Currently the museum is restoring a gigantic 1926 Marion electric shovel used in limestone quarries. (Courtesy *Sentinel-Tribune*.)

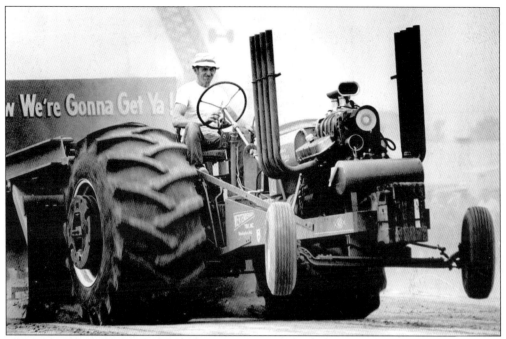

MONSTER TRACTOR. In 1962 the Wood County Tractor Pullers were chartered and held their first event at the Wood County Fair. By 1967 the National Tractor Pulling championship had arrived with a $4,500 purse and 10,000 spectators. The event is held annually at the Wood County Fairgrounds after the fair. It is the largest of its kind in the United States. Currently the entire purse is $200,000 and can draw over 60,000 visitors to Bowling Green. (Courtesy CAC-BGSU, B. Stephens.)

MONSTER NOISE. When the "pullers" are in town the sound can be heard for miles around. (Courtesy CAC-BGSU, B. Stephens.)

THE CORNER GRILL. Pictured here is downtown's memorable gathering spot that never seems to close, with its famous neon sign still operating at the corner of North Main and Court Streets. (Courtesy the author.)

THE GIANT HAMBURG. The diner seen at the far right opened in 1937 at 215 South Main Street. A giant hamburg made with a quarter pound of beef sold for a dime. The place was open seven days a week, 24 hours a day. It closed in 1982. The Elbow Room Hamburger operated at 112 West Wooster Street and the Hut over on East Wooster Street. The Centre Super Market, The A and P and the Dixie Food Town all sat along Main Street. (Courtesy *Sentinel-Tribune.*)

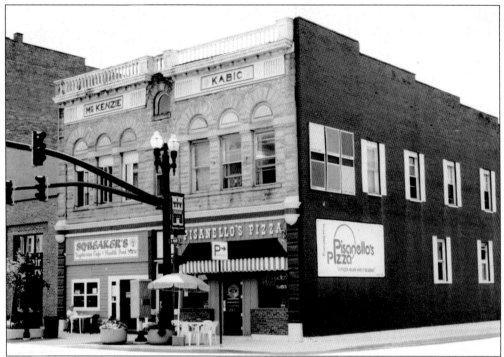

PIZZA PARLOR IN MAIN STREET HISTORIC DISTRICT. Among the almost 50 post-Civil War commercial buildings comprising the city's historic district is the 1892 Romanesque McKenzie-Kabig Block on the south west corner of North Main and Court Streets. In the past it housed the public library. Today it boasts a pizza parlor and vegetarian establishment. Restaurants, coffee shops, and cafes dot the downtown. (Courtesy the author.)

UPTOWN-DOWNTOWN. The old Hotel Brown served as the Elks Lodge from about 1919 until about 1978. It then became a popular night club with dancing upstairs. It is pictured on the far left in this photo of the Reed-Merry Block, which is now home to an eclectic mix of businesses. (Courtesy the author.)

HOWARD'S CLUB H. For many years Howard's has been a Bowling Green staple. Originally Howard's Restaurant was located where the public library now stands on North Main Street. Today, across the street, the night club with the popular bands rocks the town from the old Orme Livery Stable at 210 North Main Street under the watchful eye of the courthouse clock. (Courtesy the author.)

CALICO, SAGE, AND THYME. Bowling Green is known for its quaint gift shops and art galleries that have helped keep the town a mecca for shoppers. For many years the unique Calico, Sage, and Thyme on Clay Street has provided teas, herbs, cards, jewelry, and an endless array of cozy gift items to their loyal customers.(Courtesy the author.)

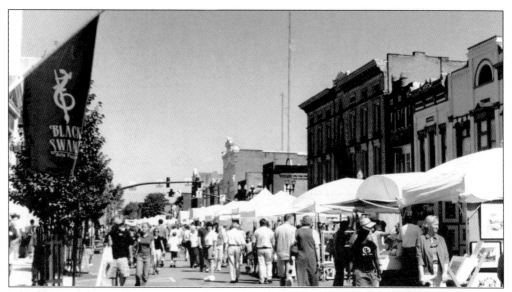

BLACK SWAMP ARTS FESTIVAL. In September each year, Bowling Green hosts the Black Swamp Arts Festival and shows off the historic downtown as well as the Main Street revitalization project that several years ago brought new side walks, lamp posts, benches, planters, and a new luster to the old boom town. The event draws over 40,000 visitors to the city of over 29,000 for the three-day art show and musical performance event. It also showcases local and BGSU talent. (Courtesy the author.)

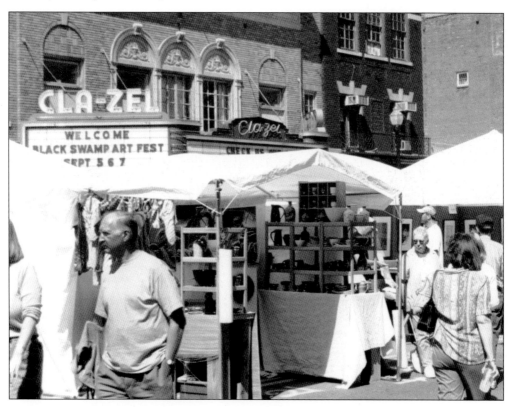

BIBLIOGRAPHY

A Brief History of Wood County and Bowling Green. 1908. Bowling Green, Ohio.

Armstrong Scrapbooks, two volumes, Wood County Public Library. Bowling Green, Ohio.

Beers, J.H. *Commemorative, Historical, and Biographical Record of Wood County, Ohio.* 1897. Chicago: J.H. Beers and Company.

Bowling Green City Directories: 1897, 1909, and 1947.

Bowling Green Sesquicentennial Commission. *Bowling Green, Ohio: A Sesquicentennial History 1833 – 1983.* 1985 Toledo, Ohio.

Chapman, Roger. *It Started With Doctors on Horseback: A History of Medicine, Marking the Fiftieth Anniversary of Wood County Hospital.* 2001. Bowling Green, Ohio, Wood County Genealogical Society.

Coller Scrapbook, Wood County Public Library. Bowling Green, Ohio.

Fletcher, Lyle Rexford. *An Historical Gazetteer of Wood County, Ohio.* 1988. Evansville, Indiana: Whipporwill Publications.

"Glacier Left Black Swamp." *Sentinel-Tribune*, 9-8-77.

"How Bowling Green Became the County Seat." *Sentinel-Tribune*, 6-12-81.

Hubbard Scrapbooks, Bowling Green volumes 1-7. Wood County Public Library. Bowling Green, Ohio

Kinney, Ken. "Black Swamp Once Ruled the Land and People." *Sentinel-Tribune*, 6-10-99.

Mabry, Michael. "*Wood County Oil Museum.*"

Men of Northwestern Ohio. 1898. Bowling Green, Ohio: C.S. Van Tassel.

Murray, Melvin L. *Fostoria, Ohio Glass II.* 1992. Fostoria, Ohio: M.L. Murray.

Paquette, Jack K. *Blowpipes: Northwest Ohio Glassmaking in the Gas Boom of the 1880's.* 2002. U.S.: Xlibris Corporation.

The Public Buildings of Modern Bowling Green. 1905. Toledo, Ohio: Heyman and Kraus.

Trsek, Sharon. *The Millikin Hotel: Building a Future from the Past, Downtown Historic District, Bowling Green, Ohio.* 1999. Bowling Green, Ohio: Trsek.

Van Tassel, Charles, Sumner. *A Genealogist's Workbook for: The First One Hundred Years of Bowling Green, Ohio 1833–1933.* 1983. Bowling Green: Wood County Chapter of the Ohio Genealogical Society.

Van Tassel, Charles Sumner, ed. *Picturesque Northwestern Ohio and Battle Grounds of the Maumee Valley.* 1901. Bowling Green and Toledo, Ohio.

Van Tassel, Charles Sumner. *Souvenier of Bowling Green – The Beautiful Crystal City.* c.1895. Toledo: Hadley and Hadley, n.d.

Weiss, Larry J. *Bowling Green State University: A Historical Photo Album* . 1980. Fremont, Ohio: Lesher Printers.

Wilhelm, Peter W. "Draining the Black Swamp: Henry and Wood Counties, Ohio, 1870-1920." *Northwest Ohio Quarterly.* Summer 1984. Bowling Green, Ohio. BGSU.

Wood County Ohio Atlases 1875–1912. 1982. Bowling Green, Ohio: Wood County Historical Society.